poster art

Innovation in Poster Design
Charlotte Rivers

RotoVision

A RotoVision Book

Published and distributed by RotoVision SA
Route Suisse 9
CH-1295 Mies
Switzerland

RotoVision SA
Sales and Editorial Office
Sheridan House, 114 Western Road
Hove BN3 1DD, UK

Tel: +44 (0)1273 72 72 68
Fax: +44 (0)1273 72 72 69
www.rotovision.com

10 9 8 7 6 5 4 3 2 1

ISBN: 978-2-88893-169-0

Art Director: Tony Seddon
Design: Simon Slater, www.laki139.com
Photography: Simon Punter
Typeset in DIN

Reprographics in Singapore by ProVision Pte. Ltd.
Tel: +65 6334 7720
Fax: +65 6334 7721

Printed in China by Toppan Leefung

poster art

EBC — Windsor

141030

Contents

01

"A poster's impact is undisputed. One simply cannot avoid looking at a poster, once one has seen it."

Uwe Loesch, Germany

Introduction

Posters play an enormously important cultural role within society. As a means of mass communication they have been used in war and peace, for everything from event promotion to the sale of goods to political battles to spreading propaganda. As pieces of artwork they are highly visible pieces of popular art and much-loved examples of design. Today, there are countless events, museums, and publications dedicated to poster design, and many enthusiasts around the world who collect and treasure them. This classic form of graphic design—which in essence has changed very little over the centuries—is as important and influential today as it has ever been.

As one of the earliest forms of mass communication, posters have a long and rich history. Before it was possible to produce images in a large format and in large numbers, posters were simply made up of text, the type for which was chosen and arranged by a printer, who then printed them using the letterpress technique. With the invention of lithographic printing at the end of the 18th century, the effect on poster design was enormous. The new technique enabled designers to transfer images that they had created onto paper using lithographic printing stones. This was a time-consuming task—one that involved drawing the image on a number of large stones, one for each color—but it was one that worked well. The basic principles of lithography are still used today to print anything from books to posters to magazines, albeit vastly updated and also much faster.

Another widely used form of printing for posters, and one of which you will see examples throughout this book, is screen printing, a technique that uses fabric and ink to create images on any material from card to paper to cloth to plastic. Its distinct appearance is favored by many designers and art directors, who see it as an antidote to the digitally produced poster.

Posters have become a visual representation of events capturing the zeitgeist of their times. Some notable examples include the Lord Kitchener Your Country Needs You! British Army recruitment poster from the First World War, Saul Bass's posters for such moviemakers as Otto Preminger and Alfred Hitchcock, and the work of Alphonse Mucha, famed for his art nouveau style of poster design.

More recently, designers including Stefan Sagmeister, Angus Hyland, and Uwe Loesch, to name a few, are known for their important contribution to the art of poster design, as is US designer Jason Munn, who is drawn to the accessibility of the form. He says, "I love the overall poster format, such a classic form of advertising and a way of getting someone's attention or sharing your political views. Posters play an important role in our culture and have incredible potential to get reactions from people and cause people to think one way or another."

For designers, posters offer a unique and much-desired challenge, and this book showcases a selection of innovative and experimental examples from around the world from recent years. Many are related to cultural or social events, from art exhibits to fashion shows, and some are commercial, but all are groundbreaking in design and are great examples of how to communicate a message to a mass audience. Together they form a collection of intelligent, witty, informative, and visually inspiring work, demonstrating the variety of typographical layouts, illustration, photography, and printing and finishing techniques that are being used by designers today. For example, Norwegian designer Karl Grandin has used wax print and one-color silkscreen on a poster for Lilla Baren, a bar in Stockholm, as well as silkscreen printing on SEF stock—which has a similar texture to flocked wallpaper—for another design; luminous ink was used to create a "glow" around the head of a character on a poster created by Brazilian designer Julio Dui at Mono to wish his clients Happy New Year; and UK designer Jonathan Ellery at Browns used gold-foil block on Splendorlux stock for his Muhammed Ali poster, created for the London show, "Public Address System."

While posters are among the most traditional and unchanged forms of graphic design—with their simple use of text, image, and the printing press—they are also one of the most impactful, creative, and memorable media, one that manages to transcend time and technology. And, despite the fact that there are far more technologically advanced methods of communication available today, posters have survived and continue to thrive. As German designer Uwe Loesch says, "Posters are still extremely important in our culture. Contrary to all predictions, the form has not lost meaning or disappeared in competition with electronic media. It has kept its place and even become more important on a global scale."

This, I believe, is testament to the power of such an instant and influential format, as well as to the brilliance and imagination of the designers who make their posters come to life.

Charlotte Rivers

02

"Posters are 'time capsules,' a social artifact documenting a specific place and event."

Robynne Raye, Modern Dog Design, USA

Artwork

Introduction

Posters have a long and rich history, and much of what has made them such an effective form over the centuries is the memorable artwork that has gone into their designs. As one of the foremost examples of modern art and design today, posters are displayed publicly throughout the world, so becoming part of our cultural language. As a result, poster artwork often goes on to become iconic, defining eras, movements, and visual trends.

From photography to illustration, the artwork used on posters must represent, or be relevant to, the subject being communicated. Where this artwork or imagery comes from is dependent on the poster. For instance, when promoting a photography exhibit, it is common for the image on the poster to be taken from the show it is advertising, and for CD releases or concerts, posters will often feature images of the band or artist in question. However, this is not a hard-and-fast rule, as the work featured throughout this chapter shows. Many designers take inspiration from poster's subject matter, but it is the ways they reinterpret this visually that makes for truly interesting designs.

Photography

"A poster should communicate and illustrate an event concisely and beautifully."

Kayrock, Kayrock Screenprinting, Inc., USA

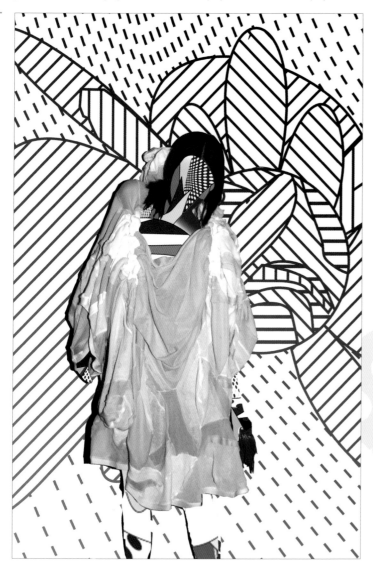

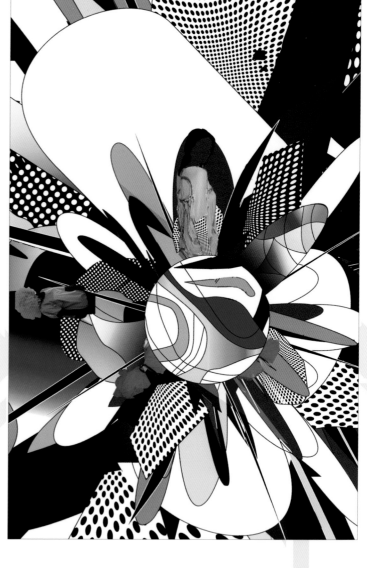

Design: **Andreas Emenius**
Country: **Denmark**

Könrøg

These two posters were created in 2006 by Copenhagen-based designer Andreas Emenius to promote the fall and winter 2007 show of fashion collective Könrøg. Emenius, who had previously created the collective's identity, was given a fairly open brief, but he was asked to design something that was surprising and energetic, and relevant to the collection.

"I wanted to create something abstract and without text," he explains. "Something with movement, colors, strength, and something instant that communicates the emotions behind the Könrøg fashion show. The main shape on both posters is based on the Könrøg logo. I then added lots of shapes that symbolize the vitality of the collective, and while one poster is made mostly out of graphic elements, the other juxtaposes graphics with a photograph of one of the outfits."

A basic paper stock and printing method were used to give the posters a "naive" feel and let the designs speak for themselves. They were sent, along with invitations, to magazines and selected people in the fashion industry. The poster graphics were carried through to brand advertising, projections during the show, and T-shirts.

Design: **Studio Apeloig**
Country: **France**

Günter Grass

French designer Philippe Apeloig designed this poster to publicize the appearance of German writer Günter Grass at the 2005 Fête du Livre, an annual foreign-literature festival in Aix-en-Provence, France. At the time of the festival Grass had recently published <u>My Century</u>, a book that explores the history of Germany in the 20th century, a century that was full of major social and political events that transformed not only Germany, but also Europe and the wider world.

"His dense prose is like a testament to the great tradition of German culture," explains Apeloig. "Inspired by this, I wanted to create a poster that made full use of the size and format, filling it up and making a powerful and grand image."

A photograph of Grass's face appears within the letterforms, making him seem totally immersed in his writing and art. The design is punctuated with a series of 100 dates from 1900 to 1999.

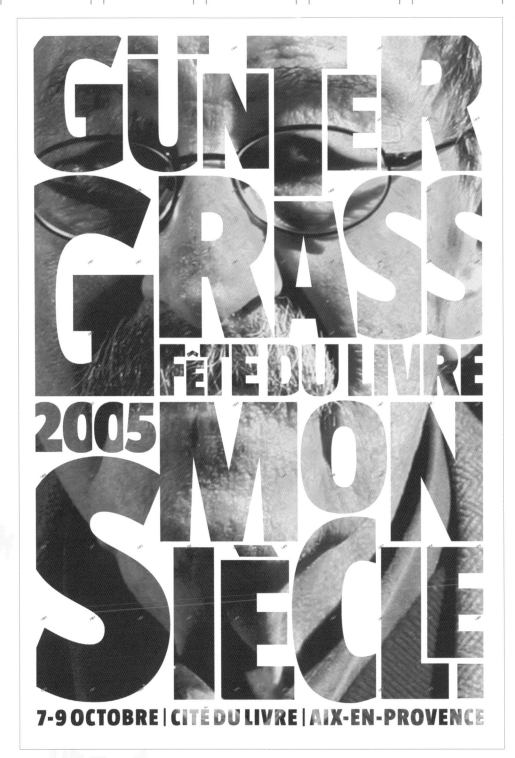

Design: **Uwe Loesch**
Country: **Germany**

Game Over/The Presence of Things/Istanbul Bye Bye!

The first poster here was created for the international competition Children Are the Rhythm of the World, which was organized by the German Poster Museum in Essen. The poster shows a child-soldier with a machine gun. Loesch has changed the color and surface of the photo to give it a camouflage effect. The main text on the poster is based on a German nursery rhyme.

The second poster was one of a series created to mark the centenary of the Ruhrlandmuseum in Essen. As part of the program for its centenary celebrations, the museum asked the inhabitants of the city of Essen to supply "objects of memory" to be exhibited at the museum as well as the stories associated with them. These objects were also used by Loesch on the posters he created to promote the show. Shown on this poster is a glass jar that was used by a mother of two during the Second World War to take water with her when she went to the air-raid shelter. "I added the fly on the glass as an expression of life," explains Loesch. The poster was awarded the Gold Medal at the International Poster Biennial in Warsaw 2006, and was included in "The 100 Best Posters 2005" competition in Berlin.

Finally, the Istanbul bye bye! poster was created by Loesch for the 10th International Istanbul Graphic Design Week, organized by the Mimar Sinan Fine Arts. He was asked to design a poster that conveyed his interpretation of Istanbul, which, as he says: "is a sentimental journey back to one of the most beautiful cities of the world, the up-coming star." The poster was silkscreen printed.

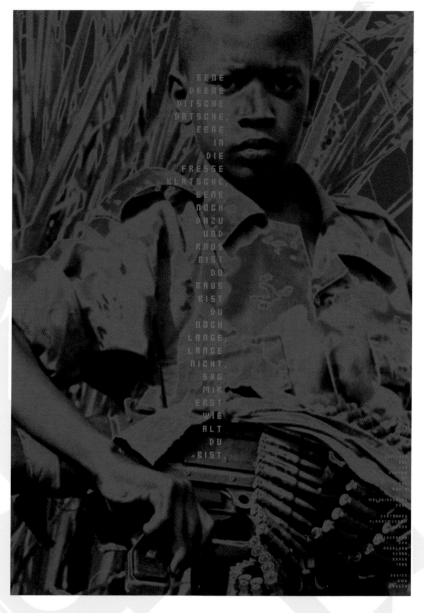

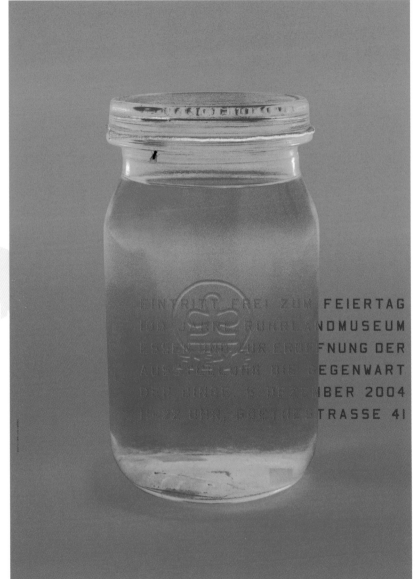

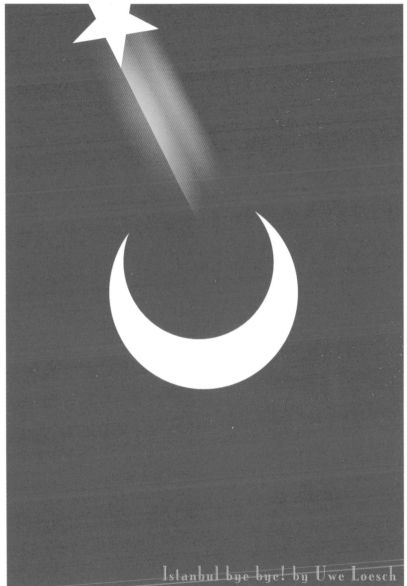

Istanbul bye bye! by Uwe Loesch

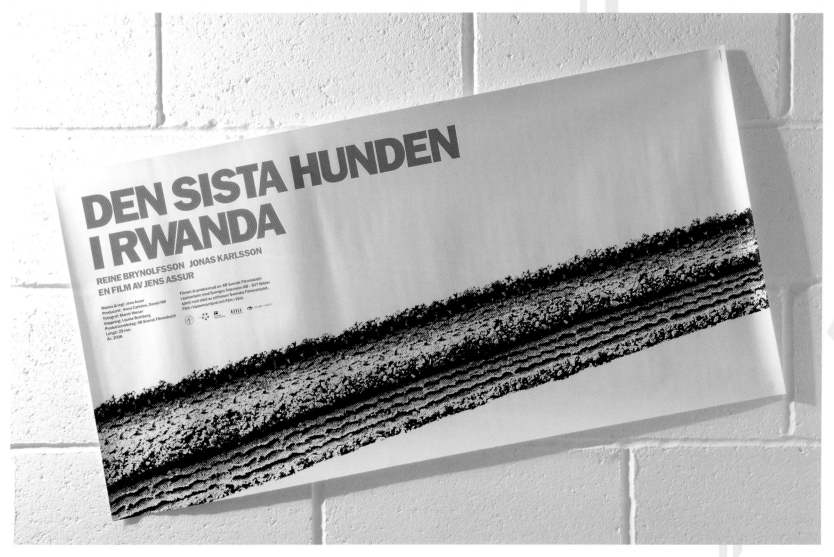

Design: **BankerWessel**
Country: **Sweden**

Den Sista Hunden i Rwanda

Den Sista Hunden i Rwanda (The Last
Dog in Rwanda) is the debut movie by
Swedish photographer and director
Jens Assur. This poster was designed
to promote its release. Based on Assur's
own experiences and feelings, the movie
is about two journalists who travel
through the shattered country. The
director's brief for the poster, designed
by Jonas Banker at BankerWessel, was
not to give too much away about the
movie, and to create a "graphic" look,
using black and red.

"We wanted the poster to look 'cool,'
but not in a clichéd kind of way—to be
'neutral' and not to give away anything
of the film," explains Wessel. "We also
wanted it to stand out from other posters
in approach, format, and paper."

The poster was printed on white
newspaper stock, and the typeface is
Franklin. "It worked very well with the
theme," adds Wessel. "It made it stand
apart from other posters, and could also
be easily folded and distributed." In

addition, a limited number of posters
were printed on better-quality stock for
archiving. The poster artwork was also
used on the cover of the DVD release,
which, in addition to the movie, features
an interview with the director and a
documentary about Rwanda.

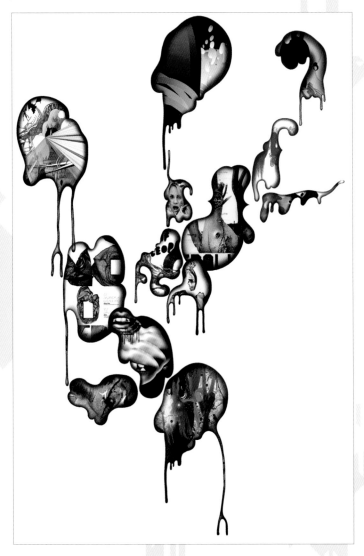

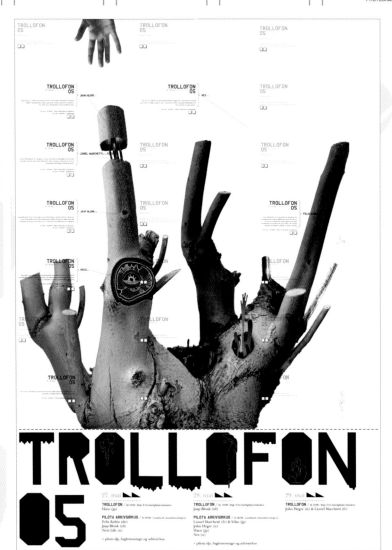

Design: **Grandpeople**
Country: **Norway**

In-House Trolls/Trollofon 05

The In-House Trolls poster was created for an exhibit celebrating the launch of Varoom magazine, the journal of the London-based Association of Illustrators. Contributors to the magazine were each invited to exhibit a new artwork at the event. Grandpeople designed this poster, which combines details of previous jobs to create this "dripping" image. It was limited to one copy only.

Trollofon is an annual festival of contemporary experimental music in Bergen, Norway. The 2005 festival had a natural science theme which had to come across in the poster design. "The organizers collected various items and displayed them around the festival premises," explains designer Magnus Voll Mathiassen. "We found our own object, a root with lopped branches."

The root image is a mosaic of 15 close-up photographs. This was done to ensure crispness, richness, and detail, and to add an element of quirkiness. Event details have been repeated to resemble a periodic table and to enable the posters to be cut into flyers with each retaining all the relevant information.

Design: **Vault49**
Photography: **Rinze van Brug/**
 Michael Creigh
Country: **USA**

The Greatest Show on Earth

This series of posters was designed by
John Glasgow and Jonathan Kenyon of
New York–based Vault49 for an exhibit
titled "The Greatest Show on Earth,"
held at the Coningsby Gallery in London.
It showcased Vault49's partnership
with some of the best photographic,
illustrative, and typographic talent
around, including Daryl Waller, Si Scott,
Rinze van Brug, Michael Creigh, and
Stephan Langmanis.

Each image is different, yet together
they form a great series of posters.
"The show was inspired by a world of
questionable morality and alternative
pastimes, and influenced by the lives and
performances of early-20th-century
traveling entertainers," explains Kenyon.
To achieve this, the combination of
illustration and photography continues
the theme of much of Vault49's work,
which challenges us to reimagine the
world in which we live.

The posters shown here were all
designed by Vault49 in collaboration with
Daryl Waller, with the exception of Stand
and Deliver, which was by Vault49 alone.
The photographers whose work features
on these posters are: Rinze van Brug on
Charmer, Michael Creigh on Stand and
Deliver, and Rinze van Brug and Michael
Creigh on Bear Tamer.

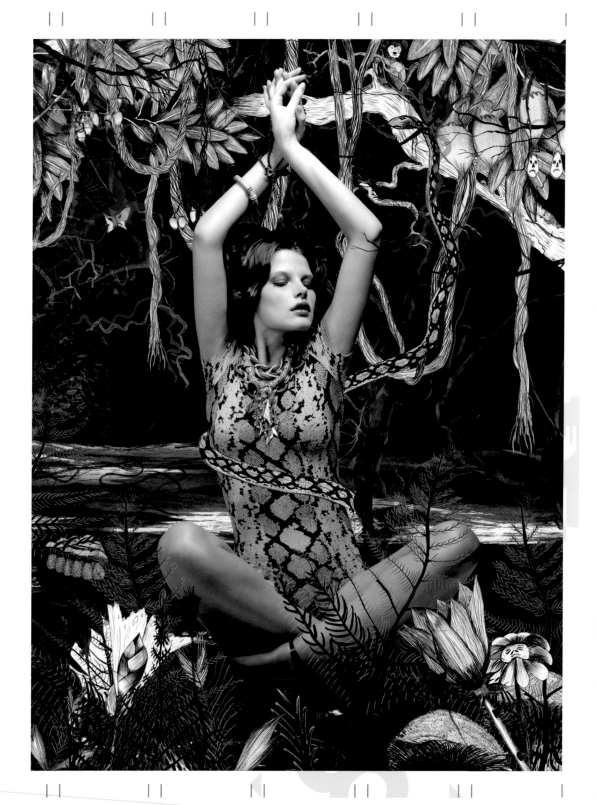

Design: **Men on the Moon/
Rosebud, Inc.**
Photography: **Günter Parth**
Country: **Austria**

United Nations

Part of an ongoing United Nations
campaign against people-trafficking
in the former Communist countries
of Eastern Europe, these posters were
created as a collaborative project
between two Vienna-based agencies:
Men on the Moon (Christoph Brunnmayr),
and Rosebud, Inc. (Ralf Herms and Fritz
T. Magistris). The purpose of the campaign
is to raise awareness among the young
women who are the potential victims of
the traffickers and to advertise a toll-free
telephone hotline. As Ralph Herms
explains, "The posters aimed to inform
people about the possible hidden risks
of a promising offer of working abroad.
At the same time, they were not meant
to intimidate or patronize young women.
Instead, the campaign aimed to make
potential victims realize that their own
intellect is their most effective means
of defense against their manipulators."

Close-ups of a young woman's face refer
to the main themes of the campaign:
"Think," "Look," "Listen," "Ask."

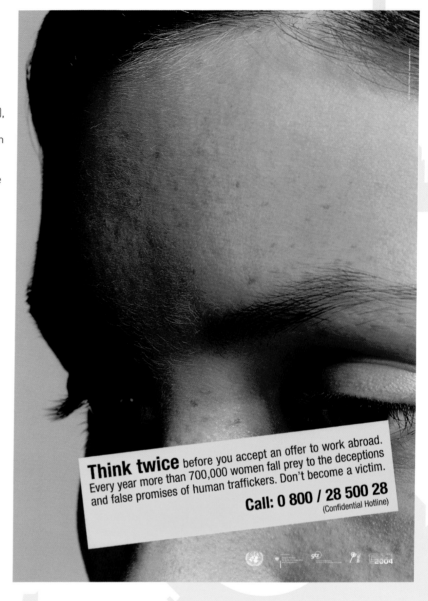

Think twice before you accept an offer to work abroad.
Every year more than 700,000 women fall prey to the deceptions
and false promises of human traffickers. Don't become a victim.

Call: 0 800 / 28 500 28
(Confidential Hotline)

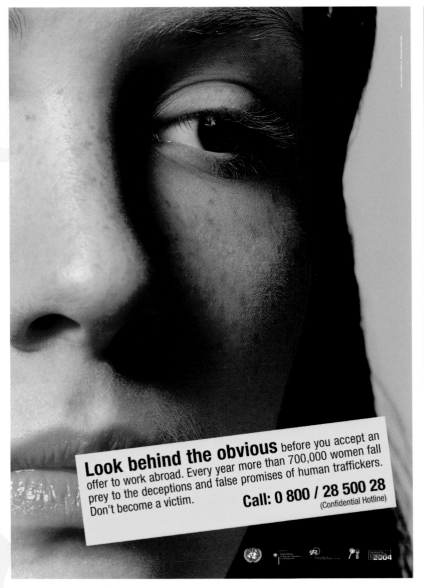

Look behind the obvious before you accept an offer to work abroad. Every year more than 700,000 women fall prey to the deceptions and false promises of human traffickers. Don't become a victim.

Call: **0 800 / 28 500 28**
(Confidential Hotline)

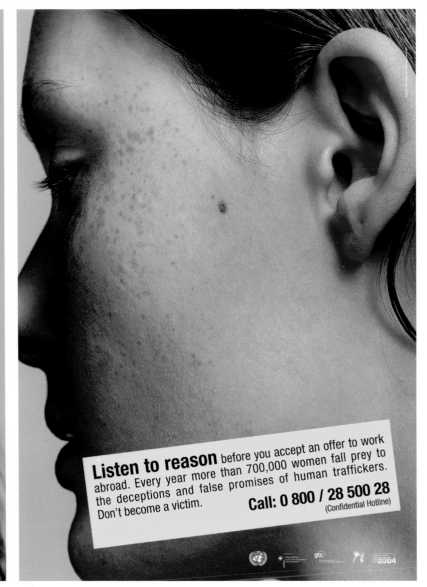

Listen to reason before you accept an offer to work abroad. Every year more than 700,000 women fall prey to the deceptions and false promises of human traffickers. Don't become a victim.

Call: **0 800 / 28 500 28**
(Confidential Hotline)

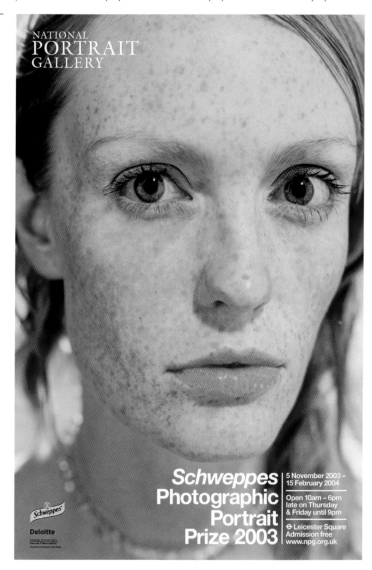

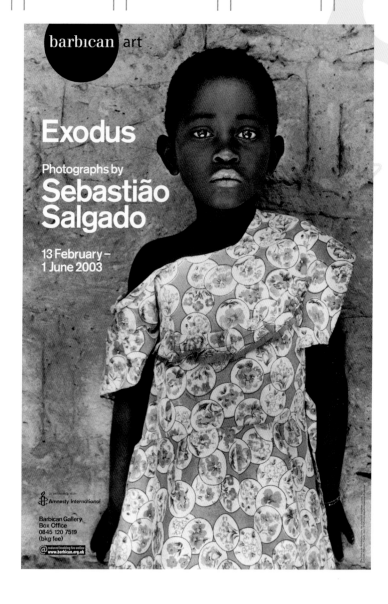

Design: **NB: Studio**
Country: **UK**

Photographic Portrait Prize/Exodus

Both of these examples use strong photography to create memorable and powerful posters. The poster for the Schweppes Photographic Portrait Prize is both a call for entries and an ad for the exhibit itself. It makes use of an unnerving image of a girl with freckles— taken by an entrant from a previous year—and was displayed on the London Underground and at the gallery.

"Exodus," put on in conjunction with Amnesty International, featured 300 black-and-white photographs taken in 40 countries, which together formed a visual history of recent socio-political and economic strife as well as natural disasters. The exhibit was arranged in sections: migrants and refugees, war-torn Africa, Latin-American disorder, Asia's burgeoning cities, and displaced

children. The picture of a young girl used on this poster creates a powerful and moving poster that gives a flavor of what the photographer and exhibit organizers hoped to achieve.

Design: **Rejane Dal Bello**
Country: **The Netherlands**

Ga Naar Claudius

This is one example from a series of posters to raise awareness of the problem of homelessness in the city of Breda in the Netherlands. The campaign, organized by City Hall, also aimed to "remind" homeless people that they could go to the City Hall if they needed help.

"The aim of this poster is to communicate the information clearly, so I chose to use a functional typeface [AG Akzidenz Grotesk] that didn't have too much 'character,' so that the infomation could speak louder than the type," explains Dal Bello.

To create the images Dal Bello photographed a model on a white background and then combined these photos with other pictures taken on the streets of Breda, including the pavement and signage.

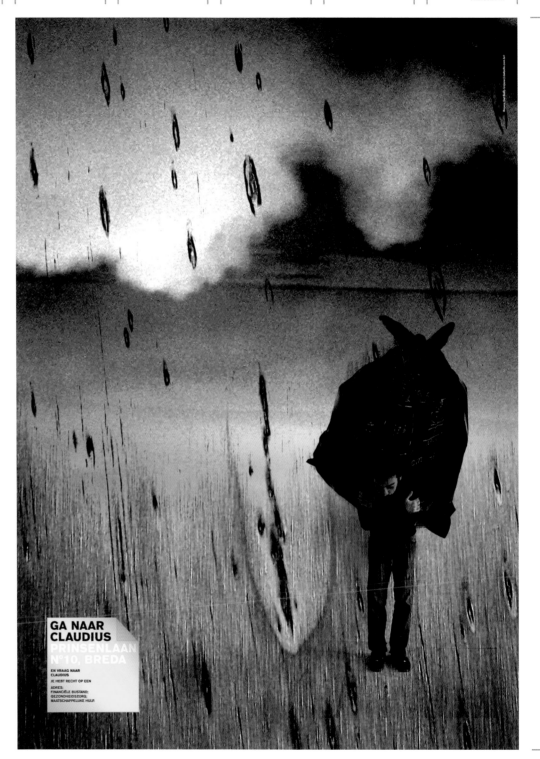

Illustration

"A good poster is an aggressive image that must bite the eyes of the viewer and open his thinking."

Philippe Apeloig, Studio Apeloig, France

Design: **Masa**
Country: **Venezuela**

Ecuador Workshop

This poster was designed for Ecuador Creative Labs, a company that organizes design and conference workshops in Ecuador. It was created by Caracas-based Miguel Vásquez of Masa design studio to promote a motion-graphic design workshop and conference that was held at two different Ecuadorian universities. The brief was to design a strong, bold image that communicated movement and animation by combining handmade collage (analog) with computer-generated vector (digital) elements.

"The design was inspired by an old paper doll that I own," explains Vásquez. "I liked the idea of the movable joints in the arms and legs. I also took inspiration from Josep Renau (a Spanish political poster designer), collages, and poster art."

Vásquez's principal idea was to get different graphic elements and play with them in order to compose and create a new image. The different visual elements used to create the poster were collected from magazines from the 1960s—the hair, legs, vintage watch—and then cut out and scanned, as were images of the metal rivets used on the legs. The mouth and small details were created either by hand or by vector graphics. The whole image was put together in Photoshop, and Ziggurat typeface was used.

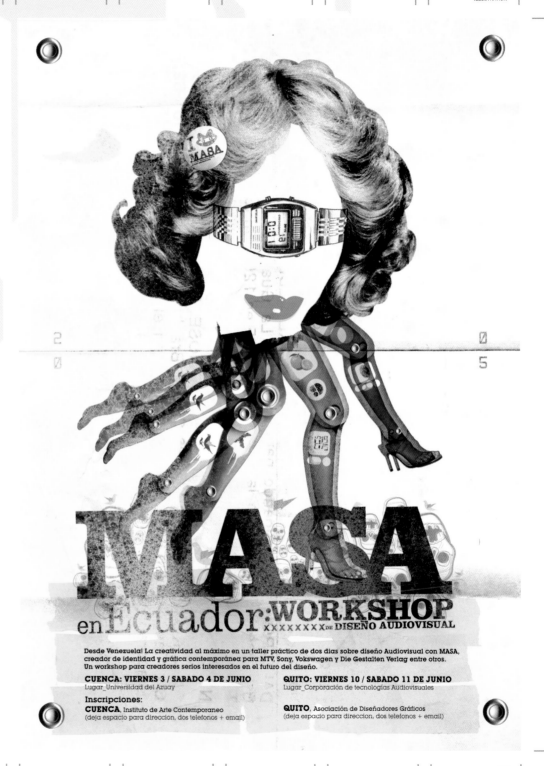

Design: **Clarissa Tossin**
Countries: **Brazil/USA**

Urban Wallpaper

This poster was created for the RES
Festival, which is concerned with digital
film. The work consists of a set of three
sheets that are applied side by side like
wallpaper. Tossin has used the lambe-
lambe technique—a method whereby a
number of smaller sheets are flyposted to
make one larger poster—which, because
of its low cost, is a popular medium in
Brazil. The paper stock used for the
technique is thin and made of low-quality
materials not unlike regular copy paper.
One lambe-lambe sheet is 26 x 37¾in
(660 x 960mm), and sets of two, three,
four, or six sheets are used for one layout
to increase the final composition size.

"All of the inherent limitations of the
lambe-lambe process were also
incorporated in the design as premises
to the creative approach," Tossin explains,
"and it was showcased at the MASP (São
Paulo Museum of Art) subway station's
corridors throughout the festival."

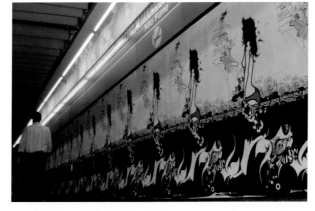

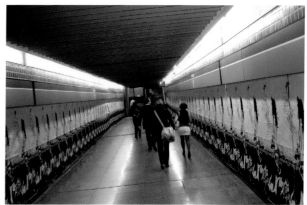

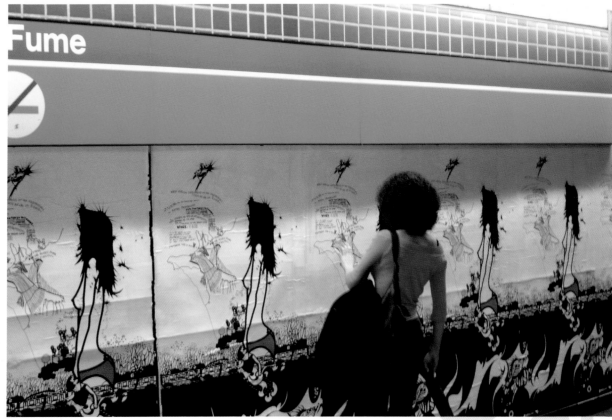

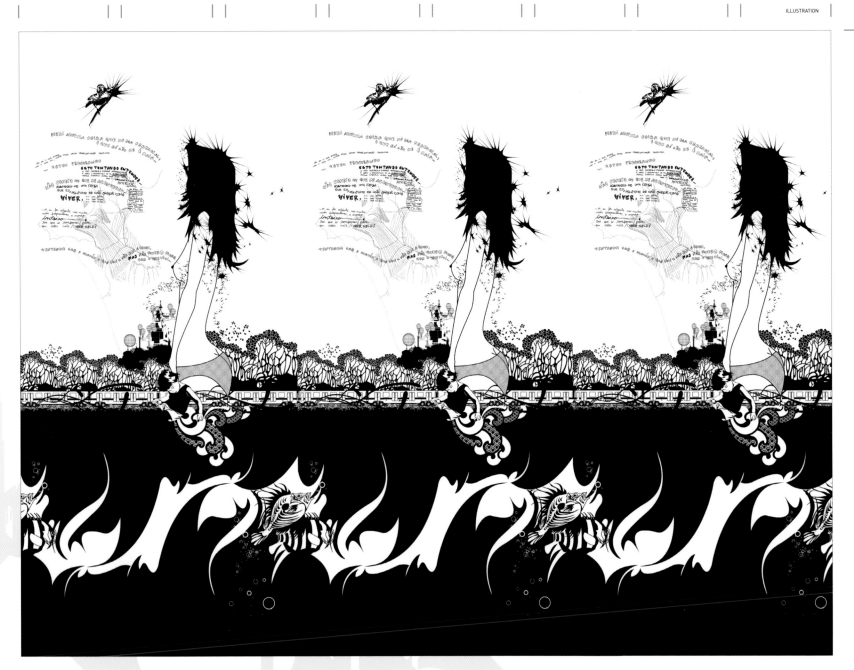

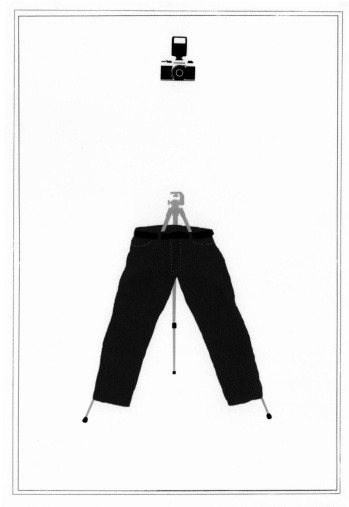

DAVID BYRNE THURSDAY, NOVEMBER 7 RHODE ISLAND SCHOOL OF DESIGN

Design: **Joe Marianek**
Country: **USA**

David Byrne

To promote a lecture at the Rhode Island School of Design by musician and artist David Byrne, titled "Evil Art and Good Advertising," US designer Joe Marianek created this poster.

"At the time of the lecture, Byrne had just released his book The New Sins, so the poster is supposed to look a little bit mean and preachy, with all the symmetry and yellow paper," explains Marianek.

"The imagery is inspired by Byrne's photography of sculptures in which he covers furniture with big clothes. The utilitarian font—Times Bold Italic capitals—is inspired by early Talking Heads album artwork." The poster was hand-silkscreened on a heavy off-white Canson eggshell. The ink for the silver tripod has a metallic base mixed in it for sparkle.

Design: **Gail Anderson, Jessica Disbrow, and Bo Lundberg**
Countries: **USA/Sweden**

Barefoot in the Park

To promote a Broadway revival of the hit Barefoot in the Park, this poster was created by Gail Anderson and Jessica Disbrow at Spot NYC along with Swedish illustrator Bo Lundberg. This production had to attract a contemporary audience; the designer's idea was to reference the 1960s but create something modern to convey that this show offered a new take on a well-loved play. "Having decided on the direction and imagery, we contacted Bo Lundberg," explains Anderson. "His style is simultaneously modern and retro, and we explained our desire to tuck all the necessary information within the flowers to create a cohesive image."

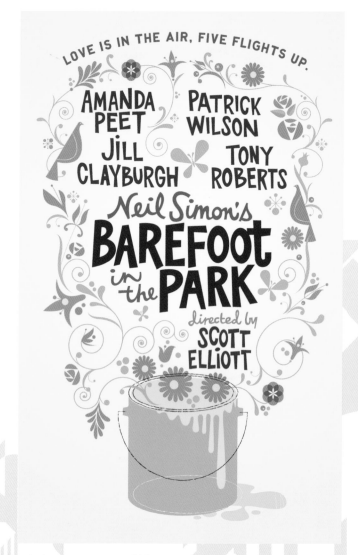

Design: **Stripe LA**
Country: **USA**

LACE

In 2006, Los Angeles Contemporary Exhibitions (LACE) invited a number of Los Angeles–based artists to participate in a poster-design project, which was part of a larger installation for a Fluxus-inspired exhibit titled "Draw a Line and Follow It." (Fluxus is an international network of artists, composers, and designers noted for blending different media and disciplines.) Each design in the project was a collaborative effort. Jon Sueda and Gail Swanlund of Stripe LA teamed up with designers Martin Venezky and Brian Roettinger on this series.

"We started by looking at selected Fluxus artifacts at the Getty Research Institute and selecting a 'score' to work from. The snippet of a score we chose was the phrase 'Result Formed Before Receipt of Client's Problem,'" explains Sueda. "Inspired by the Fluxus phrase, as well as 99-cent stores, Costco, 7-Eleven, and grocery stores near our studio, we created a 'warehouse'—posters, a flyer, pricing, packaging, and cartons—ready and waiting for a product that has yet to be determined. We generated ephemera just waiting for content to advertise an undetermined, unknowable product with photos of empty plates and blanks, stand-in typography, 'blasts' and 'banners' ready to be filled in."

The large-format series of posters was silkscreen printed.

Design: **Andy Mueller**
Country: **USA**

Lakai

Lakai is a US skateboard label, and Los Angeles–based designer Andy Mueller— who is also Art Director of the brand— designed this series of posters to promote Lakai's style and vision. He is, as he says, "surrounded by skateboarding and shoes all day," which is reflected in the design of the posters, for which he provided the photography and illustrations. "It is all about shoes and skateboards, all connecting and intermixed," he explains.

For the poster shown top right Mueller has used Fulton and Helvetica typefaces and a colorful 1960s-inspired color palette. The poster shown bottom left is based on a piece of clip art that Mueller found in a book. "The book was called <u>Crap Hound: A Book of Royalty-Free Images</u>. Although I rarely use clip art, I thought that adding the Lakai logo inside the figures made it unique and more than just a piece of clip art, and I also like how it sort of makes an 'OK' sign, as in 'Lakai is OK.'"

The poster shown bottom right could be described as a puzzle of shoes, and it features a typeface that Mueller found in a book, scanned in, and cleaned up.

The posters were displayed in skate stores around the world.

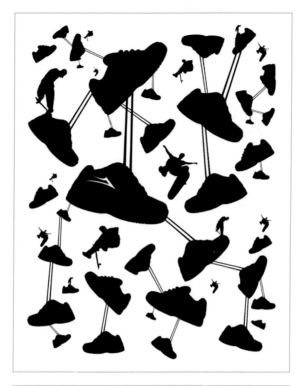

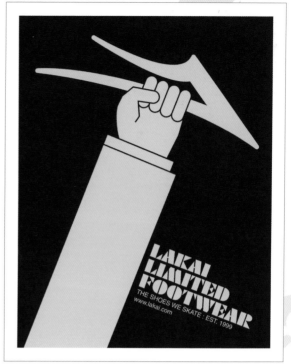

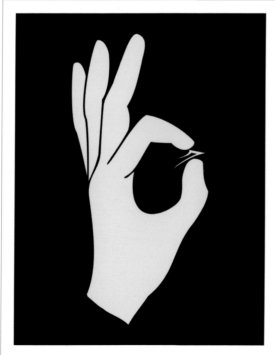

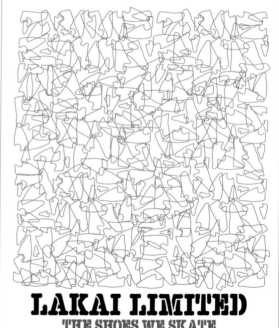

Design: **Andy Mueller**
Country: **USA**

Paint City/Paint Brush/ Tools of the Trade

These three posters were designed by Andy Mueller for The Quiet Life, a small Los Angeles–based clothing company that he runs with his wife. The posters were created to promote various clothing collections produced by the label.

"Most of my Quiet Life designs seem to have a sense of humor and are pretty simple," explains Mueller. "For instance, for the <u>Paint City</u> poster, I liked the idea of the city growing out of the paint brush, which was a doodle that got turned into a poster. Same with <u>Tools of the Trade</u>. I was thinking about the tools I use and how silly it is that I mostly use pens, pencils, highlighters, and an Exacto knife—that's about all you need, along with a computer, of course. The <u>Paint Brush</u> idea came from being a graphic designer: I leave a lot of slogans, logos, and words behind as my trail."

A number of typefaces have been used on these posters, some custom, some bought, and some found. To save money, <u>Paint City</u> was printed on about 10 paper stocks: Mueller instructed the printers to print it on any stock they had lying around, so some posters came out on blue paper, some on newsprint, some on textured stock, and so on.

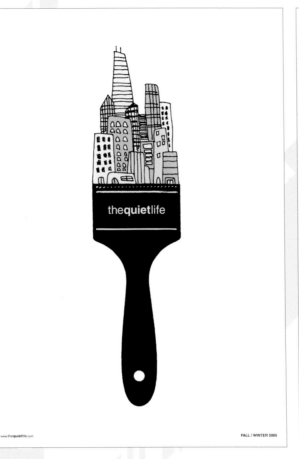

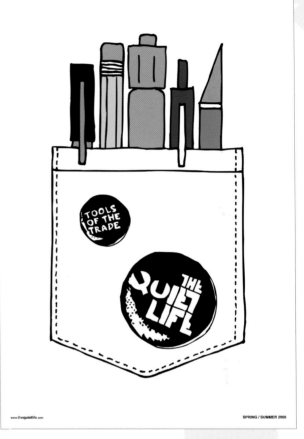

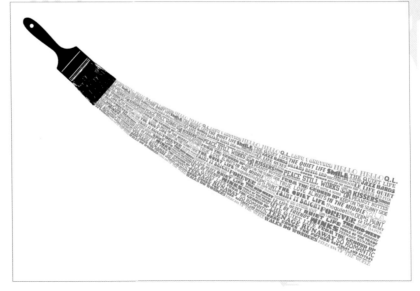

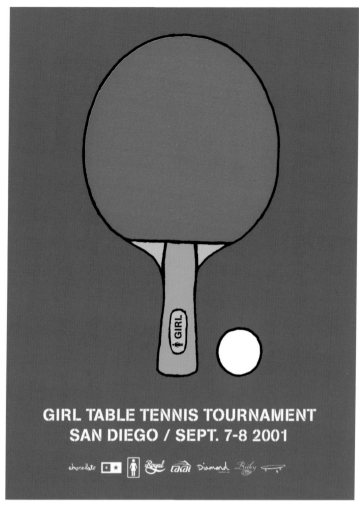

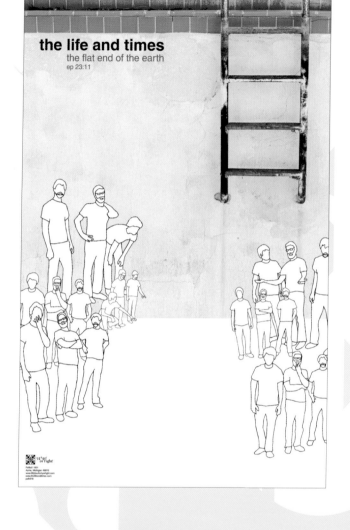

Design: **Andy Mueller**
Country: **USA**

Ping Pong/
The Life and Times

These posters were both designed by Los Angeles–based Andy Mueller. The first is for Girl Skateboards, and specifically to promote a table-tennis tournament the company organized. "One of the brand managers at Girl Skateboards simply asked me to create a visually stimulating poster to promote the event and capture people's attention," explains Mueller. "I wanted to make something you could see from a few hundred feet away, so I used a simple ping-pong-bat image and set the text using an AG Stencil. I love the typeface, nice and simple and clean, but also cool that it's a stencil."

The second poster is for US record label 54º 40´ or Fight! and one of its bands, The Life and Times. It was created both to promote the release of the band's first CD and to publicize a tour, hence the white space left at the bottom to allow the clubs and dates of the tour to be added later.

Mueller shot the pool image and then added drawn images of the band. Helvetica Bold typeface was used for its simplicity.

Design: **Angus Hyland and Fabian Herrmann at Pentagram**
Country: **UK**

The Cat Called Rabbit

"Don't Panic" is a free information pack distributed in selected stores and bars in the UK, Holland, and Australia. Each issue contains a free poster insert, sometimes produced by an established independent, innovative design company, and sometimes from entirely unknown designers or students.

Titled <u>The Cat Called Rabbit</u>, the black, gray, and white poster features intricate silhouettes of flora, fauna, and fairies and is based on a photograph of Hyland's cat sitting at the bottom of his garden. It is an image that has a great mystical, fantasy feel to it that fits well with the clubby readership of "Don't Panic."

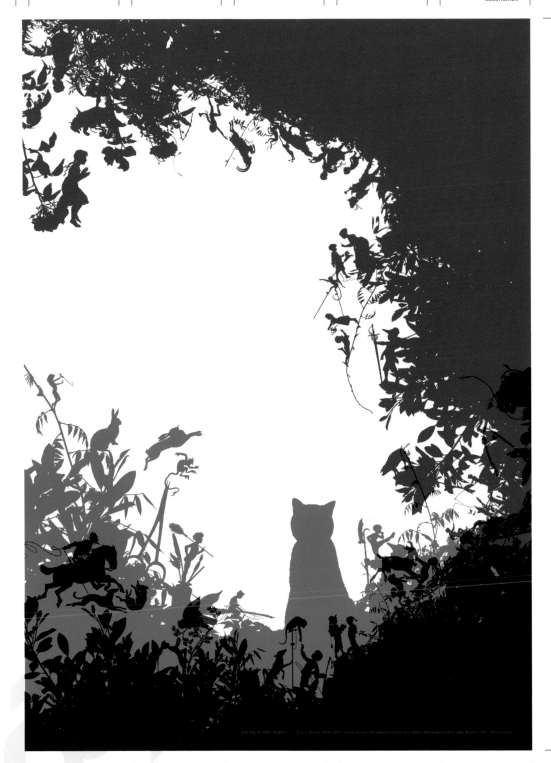

Design: **Michael Gillette**
Country: **USA**

Wild Tigers I Have Known

Wild Tigers I Have Known was launched at the Sundance Film Festival in 2006. The idea of the poster design was to get into the mind of the movie's teenage lead character, who associates his tormentors with tigers. "I wanted to quite simply link the two," explains Gillette, "to get the feeling of a looming threat."

Inspired by illustrators from the late 19th and early 20th centuries, such as Edmund Dulac and Arthur Rackham, Gillette has created the moving image of the boy and looming tiger. He also hand-drew the different typefaces for the poster.

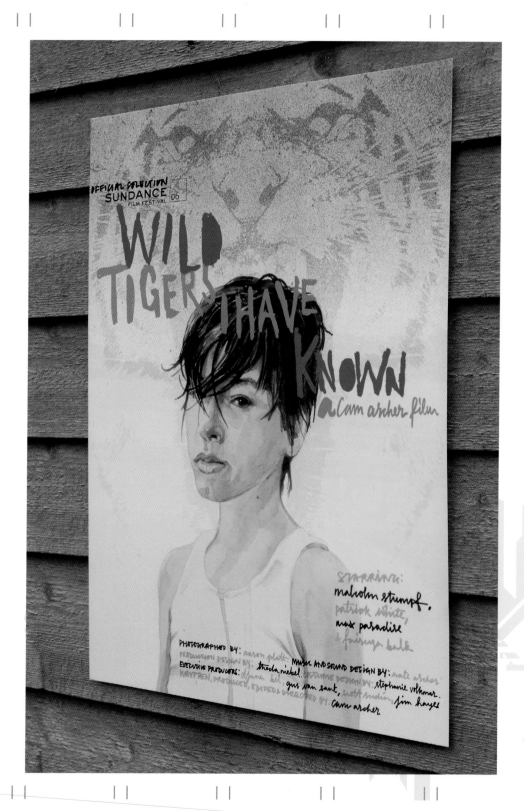

Design: **Jason Munn at The Small Stakes**
Country: **USA**

Wilco/Rilo Kiley/ Matt Pond PA

These posters were created by Jason Munn for a number of different band gigs in the USA. First here is a poster promoting a show at Irving Plaza, New York, by the band Wilco; the design was inspired by a track on Wilco's album Hummingbird. Munn has used screen printing to create a lo-fi-feel poster.

The Rilo Kiley poster, created to promote the band's show at Bimbo's 356 club in San Francisco, has a similarly lo-fi esthetic to it. In order to create the image, Munn scanned an actual brush stroke and then added in the trees at the top of the stroke in Illustrator before creating a brush image. The work was then screen-printed on an off-white stock in a limited run.

The other two posters here were created to commemorate Matt Pond PA's February and March 2006 tours of the USA. "I decided to create two posters," explains Munn, "one for each half of the tour, that, when put together, would create one large image." Again, these were produced as limited-edition screen prints on off-white stock and sold as merchandise during the tour.

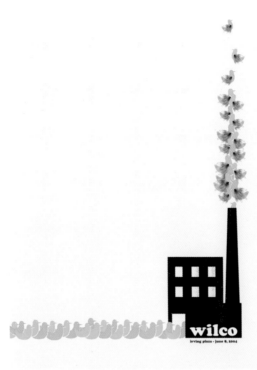

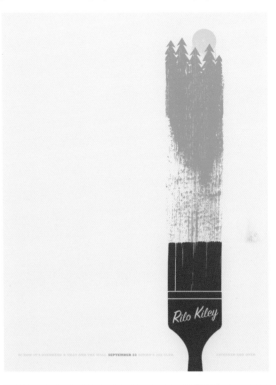

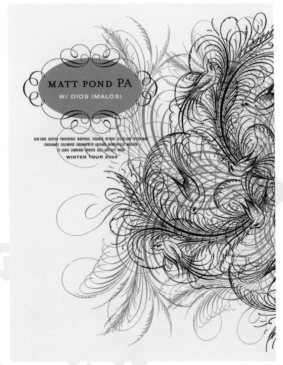

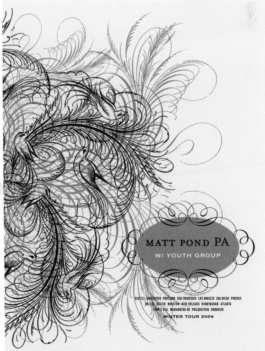

Design: **Anthony Burrill**
Country: **UK**

I Like Art

This series of posters was self-published by Anthony Burrill as a series of prints to be sold on his website. "I wanted to make something that was new, yet had all the elements of all the themes of my previous work, for people to hang on their walls as art," he explains. "I recently met up with a local screen printer, and this series is produced in collaboration with them."

All the imagery featured was taken from Burrill's graphic-ephemera collection. "I collect scraps of paper, packaging, and stickers, wherever I am," he says. Sometimes these elements spark off an idea for a piece of text, or I think of the phrase first and find an image to go with the words."

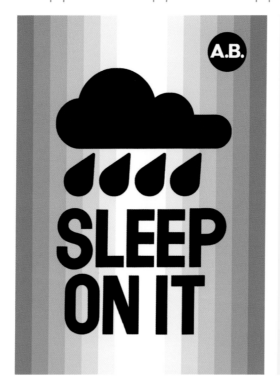

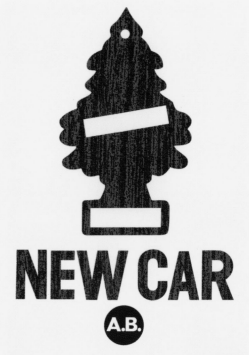

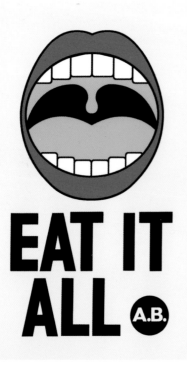

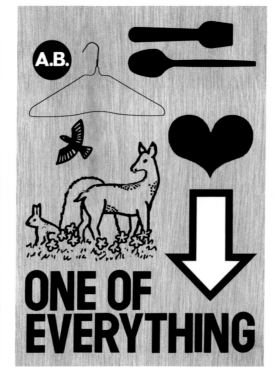

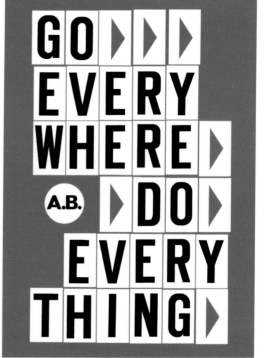

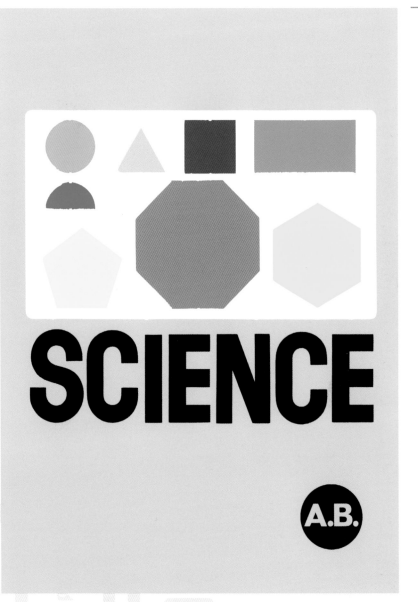

Design: **Helena Fruehauf**
Country: **USA**

Richard Jackson/Martin Kersels/Brand New School/ William Jones

These posters were created to publicize lectures by visiting artists at the California Institute of the Arts. The first was for Richard Jackson who creates sculptural machines with which to place paint on canvas. The idea behind the design was to emphasize the role of movement, repetition, and distortion in his work.

The second poster was for a lecture by Martin Kersels. The illustration featured combines different elements of Kersels' work to form a montage/collage image that was then silkscreen printed.

The Brand New School poster was silkscreen-printed on transparent paper. Brand New School's work focuses on web design and animation, and Fruehauf has interpreted their work in a playful way, using overlay and dancing figures. The leaf is an element of their identity, and the headline typeface, Malibu, was designed by one of the studio's founders, Jonathan Notaro.

The final poster was created to promote a lecture by visiting photographer William Jones. Jones has mapped out each of the 50 cities in Southern California with a Hispanic-majority population. The absence of any Hispanic people in his photographs led to the bare composition of the poster. It concentrates on the concept behind Jones' work, depicting every trivial detail of a vernacular visual language. For example, the artist's name is composed from the grocery-store lettering shown in one of his photographs.

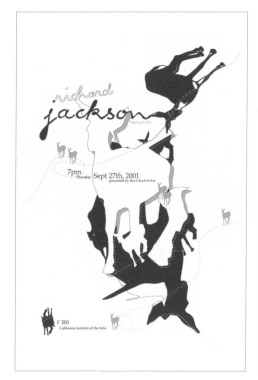

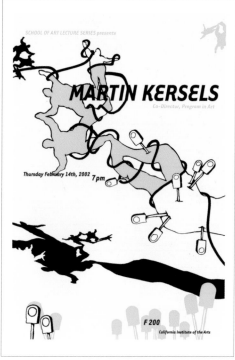

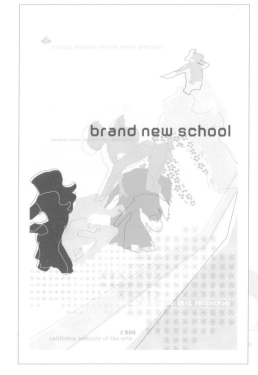

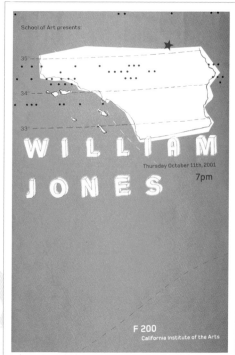

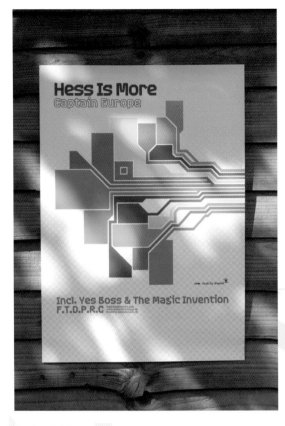

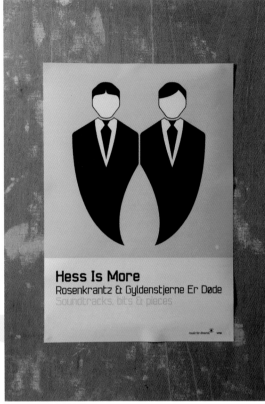

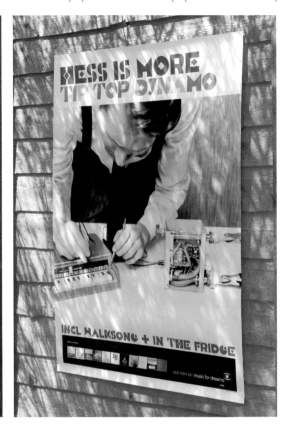

Design: **Cyklon**
Photography: **Simon Ladefoged**
Country: **Denmark**

Hess Is More

This series of posters was created for Danish musician Mikkel Hess—aka Hess Is More. The shape on the first poster, a reimagined Europe, was inspired by technical illustrations and train maps. The gradient background, made of circular forms, works in contrast with the colored shapes.

The second poster was designed to promote the soundtrack for <u>Rosenkrantz og Gyldenstjerne Er Døde</u> (<u>Rosenkrantz and Guildenstern Are Dead</u>). The brief was to illustrate two dead people without giving an impression of death. "While discussing the brief over the phone, I drew the two shapes," explains Henrik Gytz of Cyklon. "Afterward, the hand-drawn sketch was redrawn in Illustrator. The two shapes symbolize a pair of wings or two rising souls. I decided not to draw faces on the shapes to make the figures look more 'lifeless.'"

The final poster was created to promote the Hess Is More album <u>Tip Top Dynamo</u>. "I picked up on 'dynamo,' inspired by the memory that a number of football clubs from the former USSR were called Dynamo and a city name. The Chinese toy piano was used on several tracks on the album, and a combination of both these elements led me to the 'Communist look.' The wires going from the toy piano to the 'machine' express the fact that the music consists of analog recordings that have been cut up and sampled." The colors used in the title are identical to the keys on the piano, and the typeface references Russian Constructivist design.

Design: **Sweden Graphics**
Countries: **Sweden/USA**

Euroclash

Swedish designers Sweden Graphics were commissioned by AIGA—a US organization for art directors and designers in New York—to create this poster for a lecture featuring French design house M/M Paris and London-based Graphic Thought Facility.

Using a series of different shapes and forms—some block color, some semi-translucent—designer Nille Svensson created the effect of layers within the poster. "For this poster I used shapes and forms that have followed me throughout my career," explains Svensson. "I find new use and symbolism in them all the time. In this instance I was thinking about how these two design agencies want people to perceive them. They have chosen different images for themselves, and I've tried to convey them through the use of these forms."

This poster was used as a mailout invitation to the lecture, and was also displayed around the venue at the event.

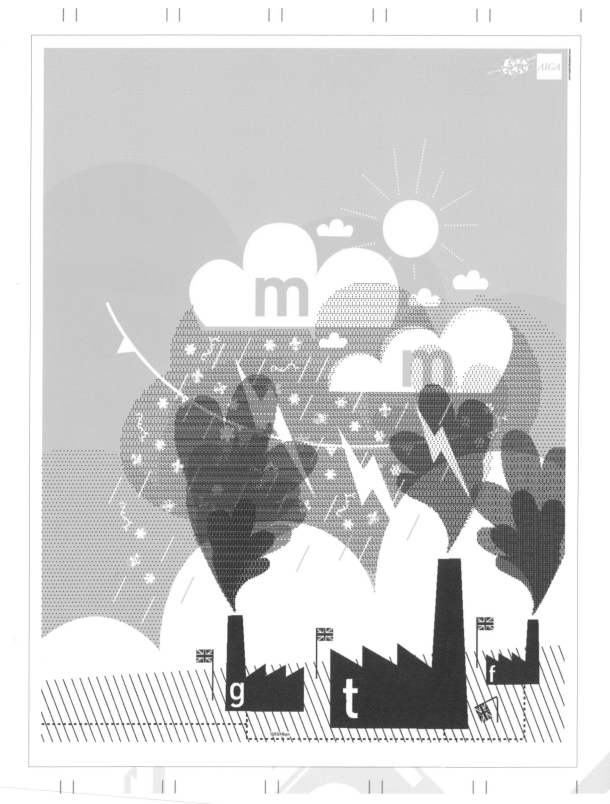

Art Direction: **Jonas Frank at TBWA**
Design: **Hjärta Smärta**
Country: **Sweden**

Apoteket

These posters were created for the Swedish pharmacy chain Apoteket's "Pain" campaign. The aim of the series was to make people aware of different kinds of pain and how to cure and prevent them. The brief was fairly open, but they were instructed to use the color green and to express pain visually.

"Aches, and especially headaches, take over your body completely—it's like an internal war," explains Angela Tillman of Hjärta Smärta. "In the beginning we made a lot of 'crazy' illustrations, and then made very simple, masked shapes to contrast with them. Green is the color used in all printed materials for Apoteket." Three different green Pantones were used for the posters, which were displayed in the windows of all the branches of Apoteket in Sweden.

Design: **178 Aardige Ontwerpers**
Country: **The Netherlands**

11 Restaurant

This series of posters was designed for 11, a restaurant, bar, and club in Amsterdam. The aim was to give an overview of the monthly line-up at 11, and to reflect its artistic objectives.

The concept of the posters' design is based on the use of different media to reflect the innovative, creative, and nonstatic character of 11, as designer Annabelle Schweinbenz explains: "The basic idea of the posters is not only to reflect the character of 11, but also the feeling of the season, regarding color, image, and use of media. In addition, for some posters we used images of the DJs and other performers in the artwork."

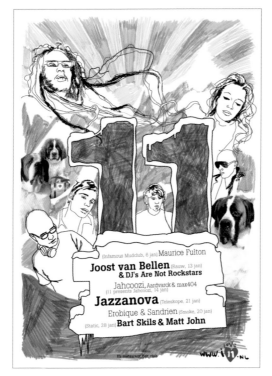

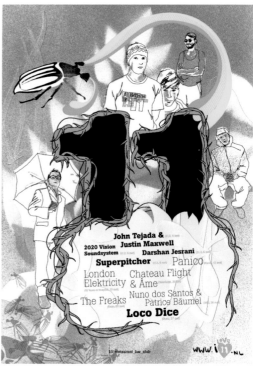

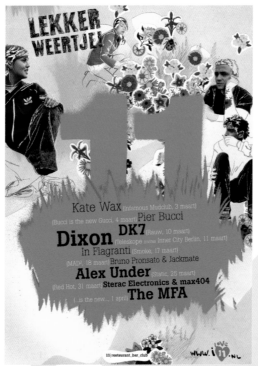

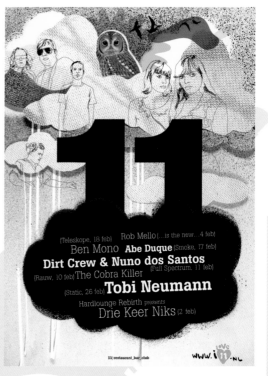

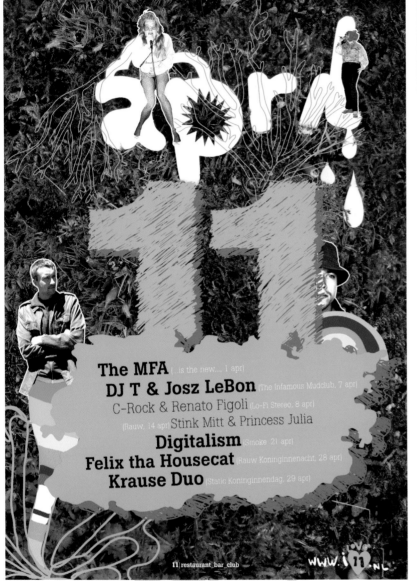

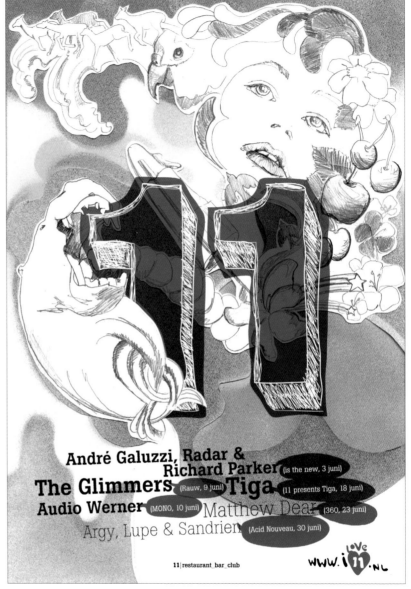

Design: **Masa**
Country: **Venezuela**

Walk this Way

These posters were created as part of a personal project by Caracas-based designer Miguel Vásquez. In his "Walk this Way" series, Vásquez has taken some of the best-loved and most collectable sneakers and created these hand-drawn illustration-based posters. Why? "For the love of sneaker culture," he says.

The sneakers featured are, of course, Adidas Superstars, Adidas Stan Smiths, Nike Air Force 1s, and Nike Vandals. "I took 15 photos of each of the real shoes in different positions from all angles," explains Vásquez. "I then selected images and made hand-drawn illustrations of each one, keeping all the important details, including the laces and stitches."

All 60 individual images were scanned and then composed digitally to create the poster. "I wanted to create a 'pattern' solution," he explains, "where the shoes are arranged to create a continuous and organic image."

The posters were printed offset on cheap bond paper stock to lend a vintage feel to the overall design.

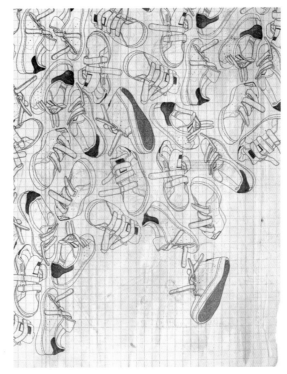
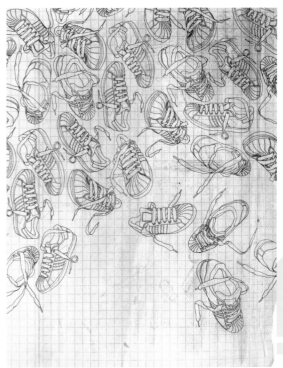
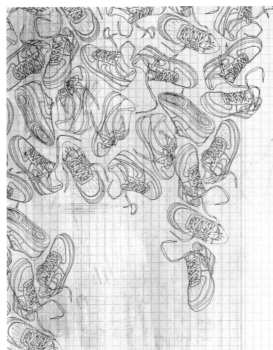
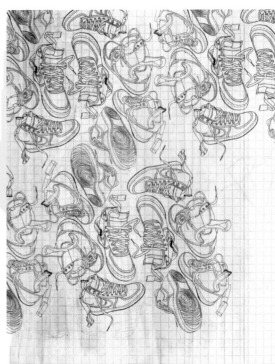

Design: **WeWorkForThem**
Country: **USA**

Star Tribune

This poster, titled Star Tribune, was designed by Michael Cina and Michael Young at New York–based designers WeWorkForThem. It was created for inclusion in a political-poster show called "Poster Offensive," which was held in 2005 in Minneapolis, Minnesota. There was no brief as such, but the designers' approach to the poster was to try to tell a story through a lot of different ideas and thoughts.

"The poster is our interpretation of America and the struggles we face," explains Michael Cina. "Many people have different views in this country, and we tried to represent some of them. We felt that by presenting a lot of viewpoints it would catch a lot of people's attention and interest. Hopefully, it helped people think further and discuss things."

The designers have used a number of recognizable icons to represent these ideas—which range from terrorism to war to Enron to Death Row—and housed them all in and around a map of the USA.

The color scheme has been kept monochromatic, so the poster does not "scream" too much.

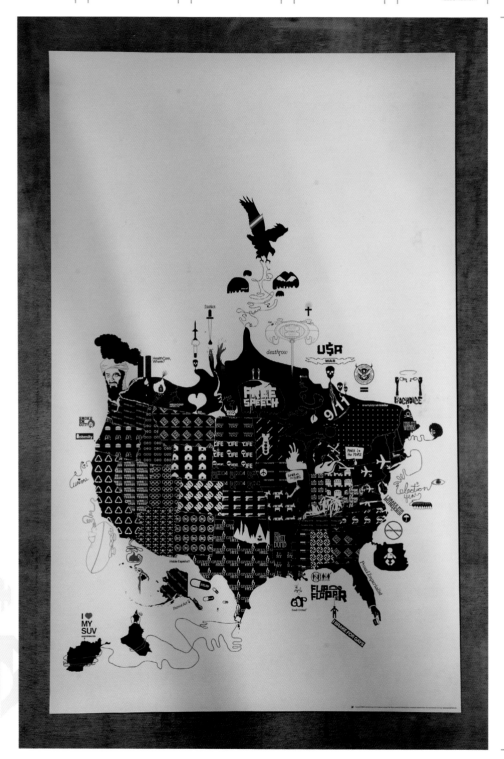

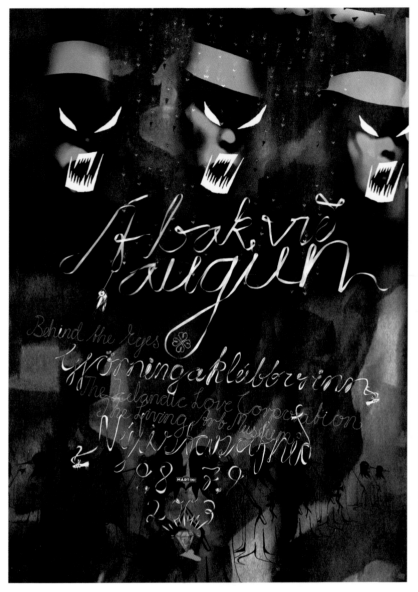

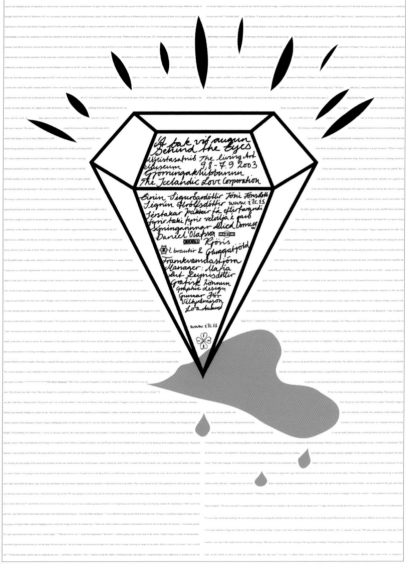

Design: Loa Audunsdottir and Gunnar Vilhjalmsson
Country: **Iceland**

Behind the Eyes

This poster was designed for The Icelandic Love Corporation (ILC), a group of three artists: Eyrun, Joni, and Sigrun. It was created to promote an ILC exhibit titled "Behind the Eyes," held at the Living Art Museum in Reykjavik. "ILC's brief was to represent a cartoony contrast between good and evil, so on the front of the poster we have three bogeymen lurking above obscure scenes of various animals,

and on the other side a shiny diamond, which in its purity looks almost divine," explains Vilhjalmsson.

The illustrations are a mixture of the Sympathy drawings (a cartoon world ILC created for soDA magazine), photographs of the ILC, and drawings by Audunsdottir and Vilhjalmsson inspired by the work of ILC. The ribbon typeface is a reference to

the silk ribbons on the top hats the artists were wearing in their Sympathy performance.

Two hundred copies of the poster were folded in a diamond shape to serve as a catalog to the exhibit. Just two colors were used: black and neon pink.

Design: **Kate Sclater and Tim Balaam**
 at **Hyperkit**
Country: **UK**

Midcentury Modern

"Midcentury Modern" is an exhibit of midcentury and contemporary furniture and collectibles, held each year at the De La Warr Pavilion in Bexhill on Sea, and at Dulwich College, London, UK. To promote the event in 2005 and 2006, designers Kate Sclater and Tim Balaam at Hyperkit were commissioned to create a series of posters.

"We were asked to give people a taste of what they could expect at the show," explains Sclater. "It was important to indicate that the show would not be crammed full of anything and everything, but would be a carefully curated display of pieces.

"As photographic imagery would come from various sources and be of varying quality, we decided instead to illustrate the furniture and objects to create simple silhouette shapes. The items and composition change for each poster, but always represent a sample of what you could expect to find at the show, with some very recognizable pieces—such as an Eames or Panton chair—and others not so well known."

The first poster was sky blue, inspired by the seaside setting of the Bexhill leg of the fair, but the color changed for each subsequent poster. However, the type was always red and the typeface used in all posters was Bryant, which was selected for its modern feel, and to counter the retro look of many of the items depicted on the posters.

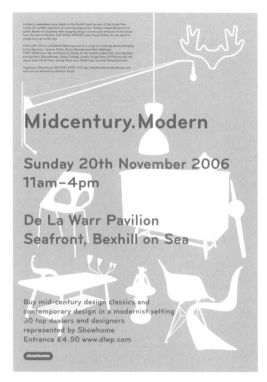

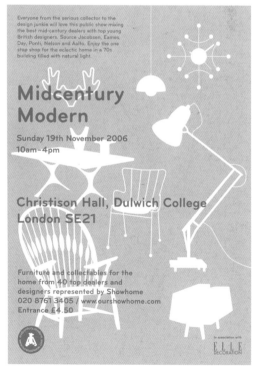

Design: **Eduardo Recife**
at **Misprinted Type**
Country: **Brazil**

Digitaria/Self-promotional

Shown here is the work of Eduardo Recife at Misprinted Type, a design firm based in Belo Horizonte, Brazil. The first poster was created for Brazilian band Digitaria to promote the band's new album, Anti. Recife also created the band's album-cover art, and used that as the basis for the imagery and design of the poster.

The image has been composed using a mixture of vector images and organic elements, such as the plant. "It is about being digital and analog at the same time," explains Recife. "The type used on the poster is the band logo, which I also designed." The poster was displayed in stores, at the band's concerts, and around town.

The other five posters shown here are self-promotional pieces by Recife, used as gifts for clients and to show at graphic-design shows.

A mixture of analog and digital collages, they are printed on photographic paper.

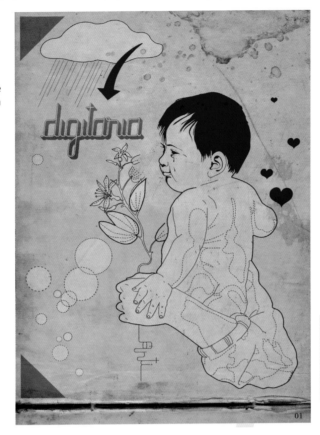

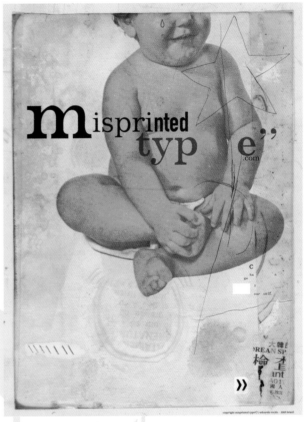

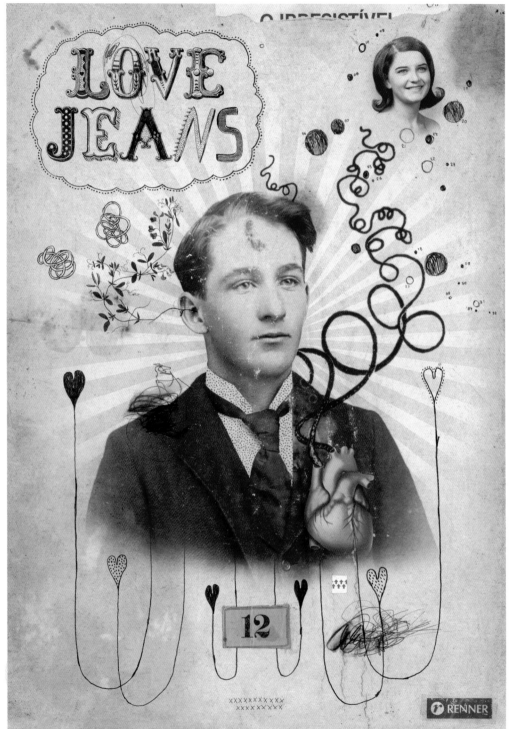

Design: **The Kitchen**
Country: **UK**

Analyse Your Space

To advertise UK home store Habitat's spring and summer range, London-based designers The Kitchen created this series of posters. They developed the strategy and slogan for the campaign—"Analyse Your Space"—and, inspired by the psychologist Hermann Rorschach, who devised the famous inkblot test, they designed a series of symmetrical "crests" for the posters.

Each crest has been composed using images of various Habitat products to create five product-category-specific posters—including lighting and storage—and one generic poster for the overall campaign. Cut-out-style graphics of the products have been put together in layers to create the images—for instance, lamps have been used for the lighting poster and coat-hangers and boxes for the storage poster. A gloss finish has been applied to all the product images.

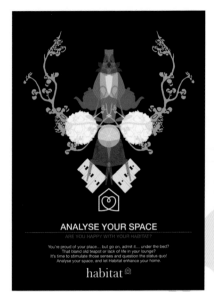

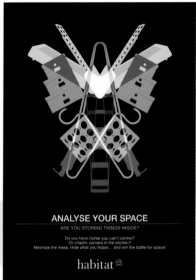

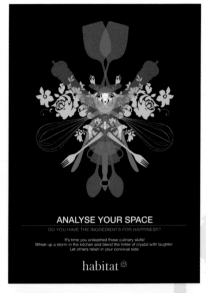

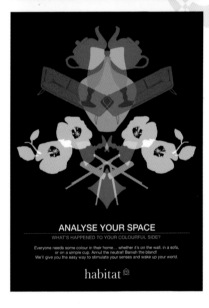

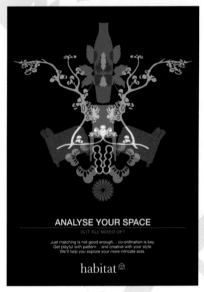

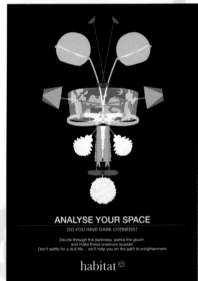

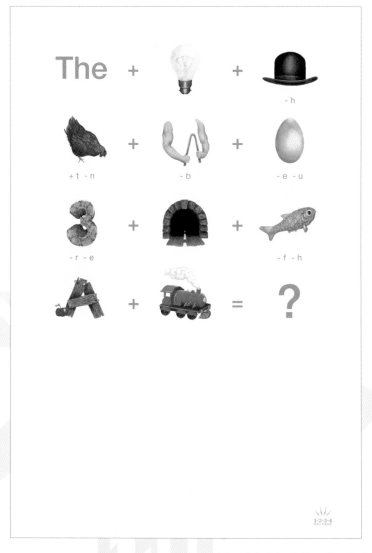

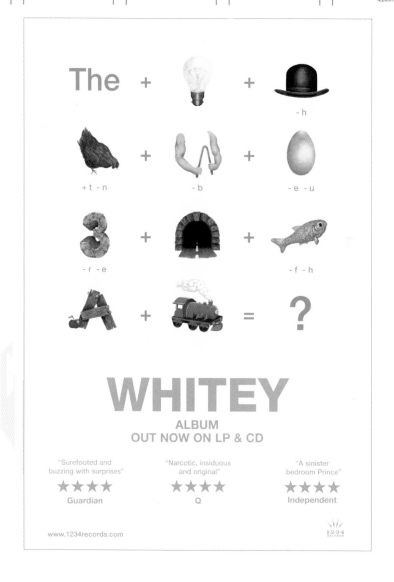

Design: **Patrick Duffy at No Days Off**
Country: **UK**

The Light at the End of the Tunnel Is a Train

Inspired by memories of puzzle books from his childhood, London-based designer Patrick Duffy at No Days Off created these posters to promote an album titled <u>The Light at the End of the Tunnel Is a Train</u> by musician Whitey.

The poster campaign was rolled out in two stages. First came the illustrated poster, the idea of which was to try to get people to work out the title of the album from the rebus, and create some interest

before the second poster went up. That second poster still refused to solve the puzzle, simply stating "Whitey Album" and the release date.

"It was great to work with an artist who didn't insist on their name being as big as possible on the artwork, and to create something that required a bit of work on the part of the viewer," explains Duffy. "Whitey was keen on using images to spell out his title, so we came up with the

idea of a rebus. We thought it would be something that people would recognize and want to solve, making the lengthy title more memorable in the process."

The illustrations were painted by Chris Graham, using gouache on heavyweight, textured paper. The idea with the imagery was to keep it quite simple and innocent without being too childish. The result is a subtle and clever poster that challenges the viewer to decode the imagery.

Design: **WeWorkForThem**
Country: **USA**

Poster Collection 2

This series of posters was designed by New York–based company WeWorkForThem. The three different artworks were originally created separately—the imagery on the poster shown bottom left was used on a DVD package for WeWorkForThem's short experimental movie <u>Enter the Dragon</u>, and the other two were originally created for a solo show by the design company—but all three were "remixed" and brought together to be shown at an exhibit at the Maxalot Gallery in Barcelona, Spain.

Inspired by their imaginations, designers Michael Cina and Michael Young have a very distinct style, one which involves using a muted color palette and placing different patterns within different shapes to make images that they, as Cina said, "felt represented us and our ideas."

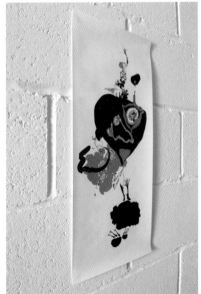

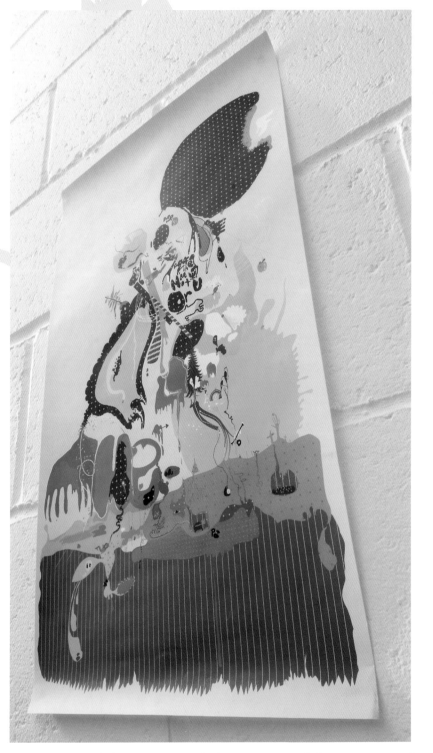

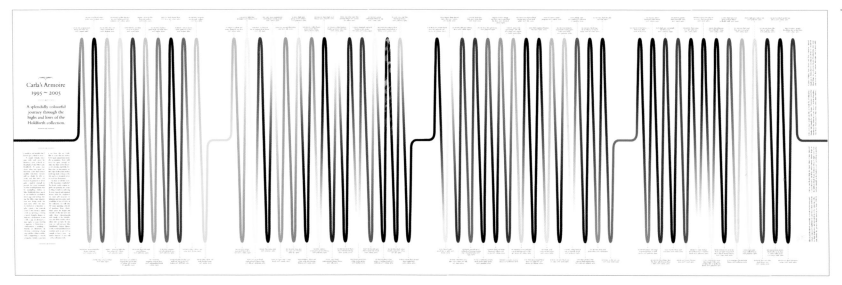

Design: **Patrick Duffy at No Days Off**
Country: **UK**

Carla's Armoire

Interested in the concept of telling stories without words, Duffy has represented every item in his girlfriend's wardrobe in this poster. As he explains, "I was thinking, 'How could I condense this wardrobe? How could it be displayed in a more minimal, but still engaging, way?'"

This diagram is his solution. He has presented each item in a series of lines that join together to form a wave. It is a calm, simple, and ordered representation of something—a wardrobe—that tends to be the opposite. Each color represents a single item. All the clothes were digitally photographed, then checked for their CMYK values. Above and below each point of the wave, text details each garment's history, color, and material. For example, "Winsmoor, black high-neck blouse, 100% polyester, 1970s." The typeface used is Bembo, to reflect the fact that much of the clothing is vintage. Though intended as a one-off piece, Duffy has recently been commissioned to interpret other people's wardrobes in the same way.

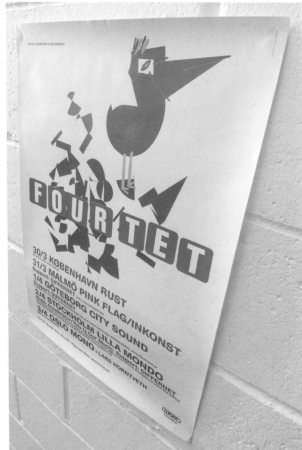

Design: **Walse Custom Design and BankerWessel**
Illustrations: **Jonas Banker**
Country: **Sweden**

Four Tet

This poster was created to advertise a series of concerts in Scandinavia by the band Four Tet. It was designed by Henrik Walse at Walse Custom Design, and featured illustrations by Jonas Banker at BankerWessel.

Banker's brief was to "make it look interesting and in harmony with the music." "I like birds, and usually start drawing birds when I'm asked to work on something," he explains. "Sometimes the bird drawings evolve into something else, but this time it felt like just the right thing." It's a simple poster, but the colors make it stand out and the imagery has a great cut-from-paper simplicity to it.

Design: **Jewboy Corporation**
Country: **Israel**

Buy Nothing Day

This poster by Yaron Shin, aka Jewboy Corporation, was created for the Green Activists organization to promote Buy Nothing Day. The aim of this event was to make people more aware of globalized mass-consumerism; people were asked to stop consuming on this particular day.

The poster, using simple three-color printing for impact, features an illustration of a shopping cart full of corporate logos—from IBM to Volkswagen to Dr. Pepper—the idea being that we are not buying "products" any more, but labels.

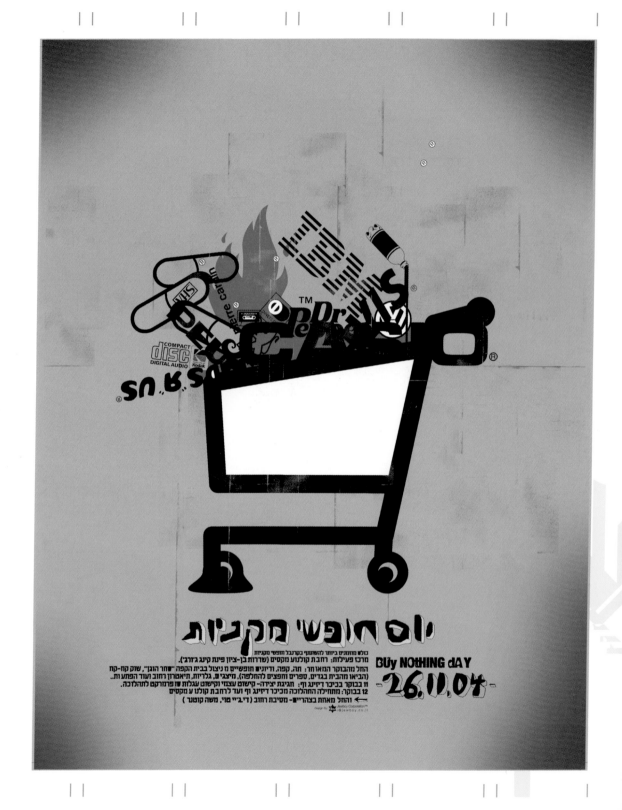

Design: **Jewboy Corporation**
Country: **Israel**

Shookultura

Yaron Shin, aka Jewboy Corporation, created this series of posters for the Shookultura Book Market, an annual event in Tel Aviv. Shookultura (shook means market, kultura means culture) was established by Avia Ben David, owner of independent book publishers Sitra Ahra, in response to the lack of events for nonmainstream publishers.

"The idea for these posters came from thinking that book-reading is like a sport for the mind," explains Jewboy, "and, pushing that further, alternative-book-reading is like taking extra risks at different sports."

Following this idea, he has created a series of images that show illustrated characters practicing different sporting activities with an element of the extreme about them—some with seriously painful-looking injuries. "With each poster I produce as the event progresses, people want the injuries to become more and more harsh!" he adds. "This is an ongoing project, so I have no idea how to go further with those injuries."

The posters, which use a custom-made typeface, were printed as mini-posters and displayed in groups on public walls around Tel Aviv.

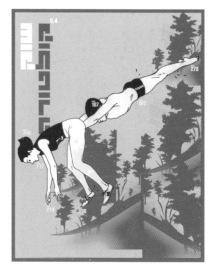

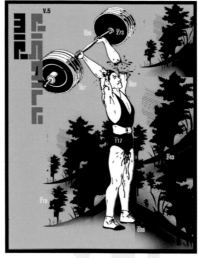

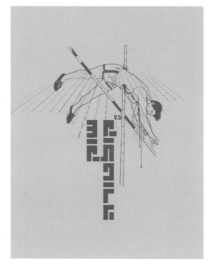

Design: **Gustavo Lacerda**
Country: **The Netherlands**

AKV/Post St. Joost School

This series of posters was created by Dutch designer Gustavo Lacerda for the postgraduate department of the AKV/Post St. Joost School in the Netherlands. The posters promote three different courses available to students at the school: Fine Art, Photography, and Graphic Design.

Inspired by the school building itself, the typeface used for the text was created using the pattern of the windows at the school. To do this, Lacerda made a grid from the windows and then created a complete alphabet. "As the building is also a strong factor that the three courses—Fine Art, Photography, and Graphic Design—have in common, I went there to look for images," he explains.

He then created the artwork for use on the posters, using silhouettes of different bits of machinery and equipment used in the school to create the "crazy, impossible machines that exist here." He devised the school logo from train, bus, and airplane tickets—trains for Fine Arts, buses for Photography, and airplanes for Graphic Design.

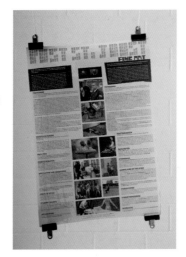

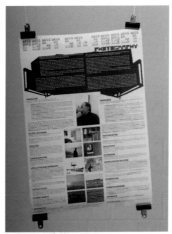

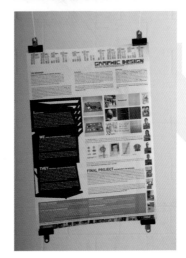

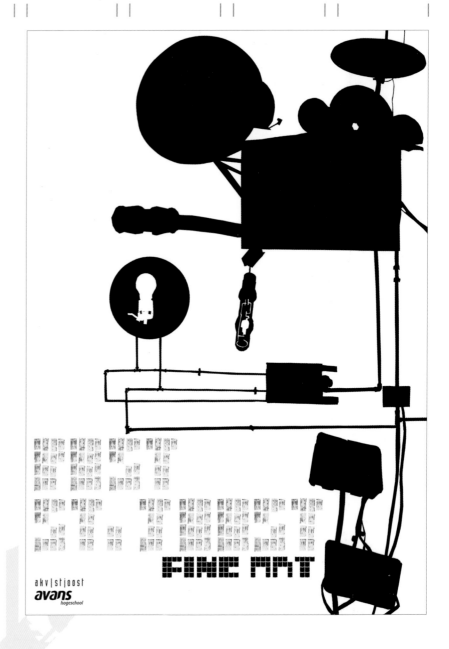

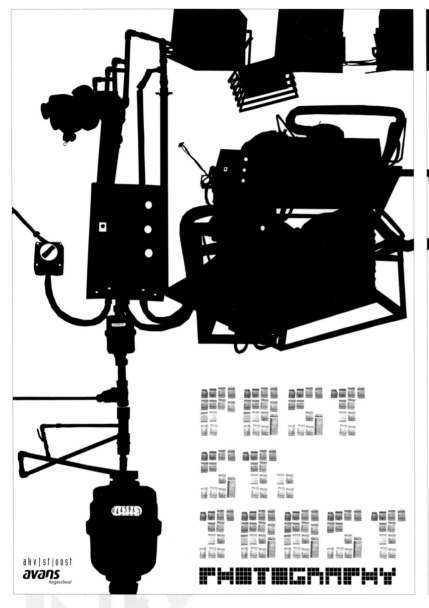

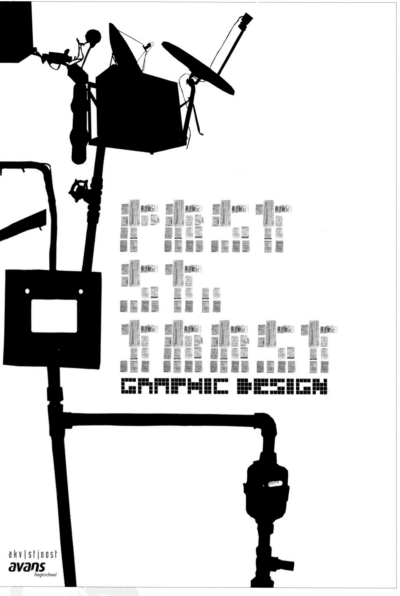

Design: **Masa**
Country: **Venezuela**

Hotel Fox: Wrestler

This poster was created by Caracas-based designer Miguel Vásquez as part of the Volkswagen Fox Project at the Hotel Fox in Copenhagen, Denmark. Vásquez was one of a number of designers invited to decorate a room at the hotel as part of a PR campaign by Volkswagen to promote the Fox model.

"The poster relates to some Mexican-inspired imagery that I used in the design of my room in the hotel," explains Vásquez. "To create the posters, I took a Mexican wrestler's mask and did a photoshoot using a friend as a model. I then chose an image, printed it on bond paper, and drew over it with a black marker, drawing continuous lines without stopping or lifting the pen from the paper. The stitches were created using different marker pens."

The posters were printed using offset litho, twice, in order to create the "blurred" effect. Low-cost bond paper stock was used to add a vintage feel to the overall design.

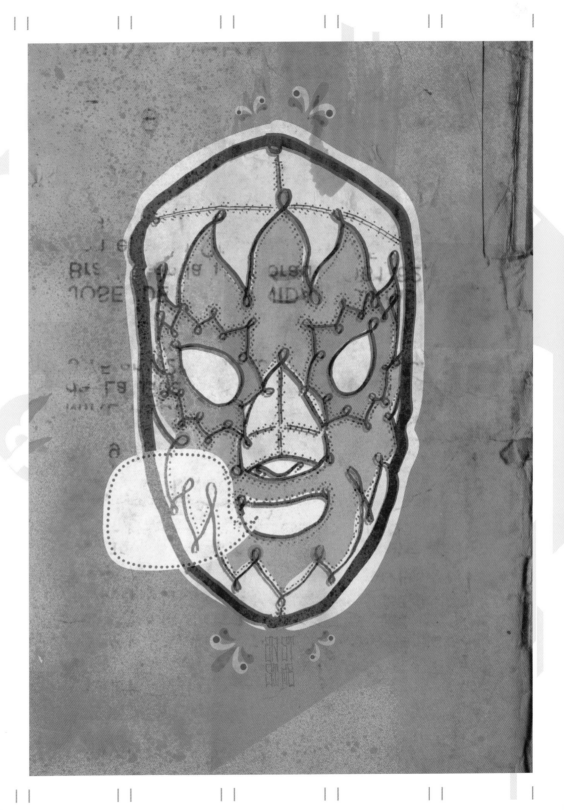

Design: **LAKI 139**
Country: **UK**

AURA

This poster was created to advertise the launch of <u>AURA</u>, a magazine celebrating graphic communication, which has mutated and expanded from the association of traditional graffiti art.

<u>AURA</u> Issue One was printed in a limited-edition of 139. Each cover is unique, making it a highly collectible and rare first edition. "I wanted each buyer to have a record of every cover, so it seemed obvious to make a poster with all of the individual covers on it," explains designer Simon Slater. An A1 (23⅜ x 33⅛in/504 x 841mm) poster was created for the street art collective Grafik Warfare's exhibition "Outside In," and buyers of the magazine received an A4 (8⅛ x 11⅝in/210 x 297mm) copy.

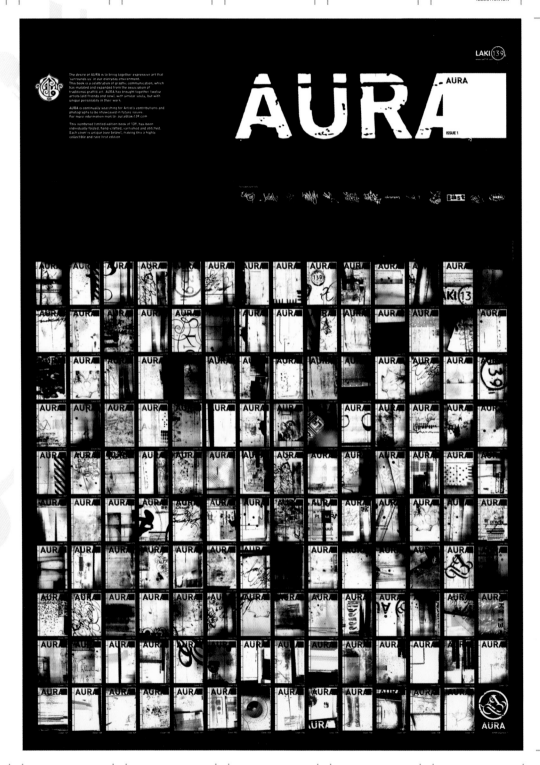

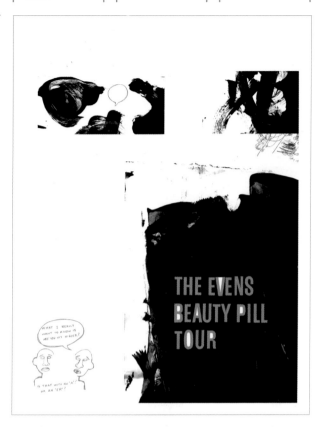

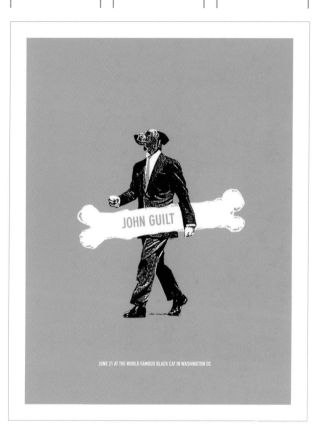

Design: **John Foster**
 at **Fuszion Collaborative**
Country: **USA**

The Evens and Beauty Pill/
John Guilt/ City Goats

The first poster shown here was designed to promote a European tour
by Dischord Records labelmates The Evens and Beauty Pill. Foster was asked for something more art than design. "I started by drawing things based on making a duo [The Evens are a two-piece band] and taking a controversial line from a Beauty Pill song," explains Foster. "I then started building the other elements from doodles and sketches as well as painting on a sheet of paper and then xeroxing it." The typeface used is from a xerox of an old type-spec book, from which Foster cut out individual letters and built the words. The remaining type is hand-drawn.

The next poster was created to advertise a performance by John Guilt. "This was the second poster for the band, and after trying to convince them to go with

a simple, direct image on the first they were more receptive," explains Foster. "I just needed to capture the working-class nature of the music and the sense of striving for something more than the drudgery of daily life." To this end Foster created a vector drawing of the body and bone and used a manipulated and xeroxed dog's head for the topper. The blue color is there to imply the "working-class, blue-collar" theme. In addition to the poster the imagery was also printed on T-shirts.

The third poster was designed to promote an earlier tour by the band John Guilt. "The band's songwriter was drawn to my messy, textured work" explains Foster. "I assembled various images using halftones of photos from hunting manuals. The type is from an old type book that I manipulated on the computer, printed

out, xeroxed, scanned, and placed." Some overprinting was carried out in the silk-screen process to give the image depth.

The final poster was designed for Galaxy Hut, a club that showcases live music. The poster was designed to promote a performance by the rock band City Goats, and to be a commemorative piece for sale following the show. "I built the background by smacking some paint onto illustration board that I scanned in, and then built a vector cityscape on top of it. The pose and suit are swiped from a super old-fashioned ad, and the goat was chosen after a great deal of research finding just the right face to halftone. The horns, bubble, and type are hand-drawn."

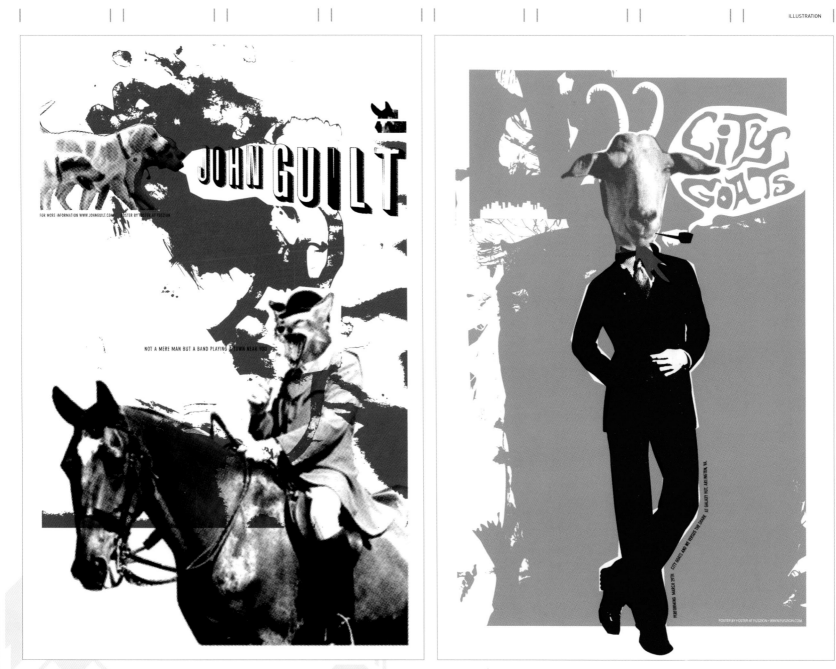

Jason Munn, The Small Stakes, USA

Which are your three favorite posters of all time?
Firstly, Dirk Fowler's American Analog Set poster. What makes it so amazing is that he applied the ink to the paper by inking the record and letterpressing it to the paper. It's a great solution, and perfect for the band. Then there is Jeff Kleinsmith's first Death Cab for Cutie poster. I love the dual image of the woman's head and the fish. I saw this poster while I was a student, and it really made an impression on me. Finally, Aesthetic Apparatus' first Spoon poster. I love how this poster is stripped down to the essentials and makes use of space. If you are a Spoon fan you get the poster right away."

What is the key to designing a good poster?
To see a thought process behind the design of the poster and how it relates to the specific event the poster is advertising.

How do you approach the design of a poster?
I usually start with research and sketching out ideas. I usually spend more time thinking than anything else. Once I have an idea, I try to figure out how to get the idea across the best, whether that be through found images or something else. I do most of the layout and finishing in Illustrator.

What inspires the creative idea behind each poster you design?
Since most of the posters I do are for bands, it is the music. I try to make a poster that is a good introduction to the band or their live shows.

What do you most enjoy about designing posters?
The overall format of the poster. It's such a classic form of advertising, getting someone's attention, or sharing your political views. It's such an accessible format.

What is the most important job of a poster?
To get someone's attention, to draw them into what the poster is advertising or the message the poster is relaying.

What would you like to design a poster for?
I would like to be able to design some movie posters. I love the sense of color and space that a lot of the older movie posters from the 1950s and 1960s had. Like the work of Saul Bass. One poster that I've really liked over the past couple of years was the poster for Sideways. It was refreshing to see that among all the other posters hanging up outside the theater.

What role do posters play within our culture?
I think posters play an important role in our culture and have incredible potential to get reactions from people and cause people to think in one way or another.

Robynne Raye, Modern Dog Design, USA

What is the key to designing a good poster?
Keep it simple; make it smart and engaging.

Once briefed, how do you approach the design of a poster? What is the process from start to finish?
It's different for every poster, but the one constant is that I do a lot of thinking before I go to the computer or pick up a pen. Typically, I'll start by discussing some aspect of the assignment with my studio mates. Then maybe I do a little research on the Internet. From that point it really just depends—sometimes I dive right into the computer and other times I turn on the waxer.

What inspires the creative idea behind each poster you design?
There's no formula, but if you're going to corner me I'd say that it's important to relate to the subject matter in as many ways as possible. For example, I could never do a poster supporting the Republican Party.

What do you most enjoy about designing posters?
In general I would say it's the freedom to be expressive. Secondly, size does matter because working "big" is great fun.

What would you say is the most important job of a poster?
To communicate at a distance.

If you had the choice, what would you like to design a poster for, and why?
The circus, because it would be a lot of fun and I think I could wangle some free tickets out of the deal.

What role do you believe posters play within our culture?
Posters are "time capsules," a social artifact documenting a specific place and event.

Who are some poster designers you find inspirational?
My taste changes quickly, but lately I've found a lot of inspiration in Jesse LeDoux's work (jesseledoux.com) and from designer Zeloot (zeloot.nl).

03

"Good posters are obvious both in content and form."

Uwe Loesch, Germany

Typography

Introduction

There is a great deal of interesting, experimental, and bold use of typography in the world of poster design. The inherent nature of the poster format means that it is one of the few forms of graphic design in which words can be set using an almost unlimited point size, whether that be small or large.

Typography can appear as text or as image—the designer can use it as artwork or as it was originally intended, to communicate a message in words. The aim of this chapter is to show how this can be done in a number of different and often experimental ways, from using words to create images of people, to creating words using computer-desktop icons, to completely filling the poster with text.

As Image

"Posters are becoming so much more sophisticated that maybe you don't have to read it—or there isn't anything to read in the first place—but still the message gets across."

Jonathan Ellery, Browns, UK

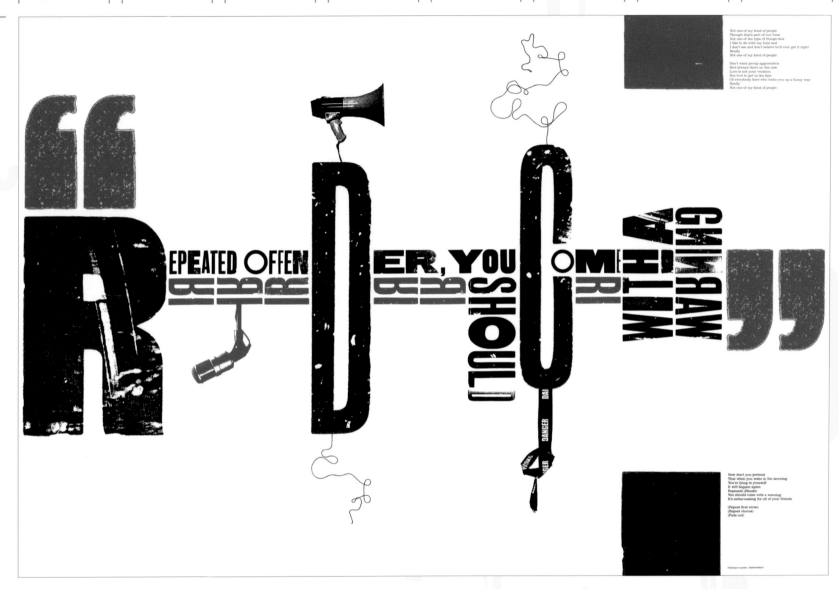

Design: **Patrick Duffy at No Days Off**
Country: **UK**

Repeated Offender

This poster, which was printed on an uncoated stock, was designed by Patrick Duffy at No Days Off as an extra to be given away with the Repeated Offender seven-inch single by British band The Rifles. All campaign elements for The Rifles' release were based on letterpress typography, and that theme was carried through to this poster.

Duffy took a lyric from the song, and used it to create a typographic image. "The band are a rock'n'roll band in the great British tradition, so I wanted artwork that would feel traditional, classic, have a bit of a rough edge, and avoid the usual rock clichés," he explains. "I've always loved the look and feel of letterpress. It was great to be able to bring it into a contemporary setting with a new band on the scene."

Art Direction/Design: **Corey Holms**
Creative Direction: **Charles Reimers**
Country: **USA**

American Splendor

This poster promoted the movie adaptation of Harvey Pekar's autobiographical <u>American Splendor</u> comics. Holmes was briefed to create a poster that would present the movie as alternative as well as showing its comic-book roots.

"The movie centers around a boring, average guy. I wanted the design of the poster to reflect this," explains Holms. "Because he worked at a hospital archiving files, I used colors that reference that life—the colors of manila folders, blue stamps, and so on."

The "scribbles" on the poster are meant to evoke the daily frustrations of Pekar's somewhat mundane working life, and the logo is taken directly from the original comics. The background panels are based on comic-book layouts.

The poster was printed on both sides, with the inverse image on the back printed slightly lighter, the reason being that the poster would be placed in a backlit frame, and this keeps the image from washing out when lit from behind.

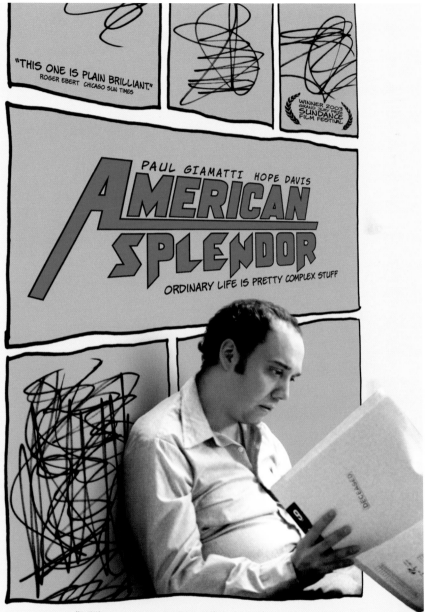

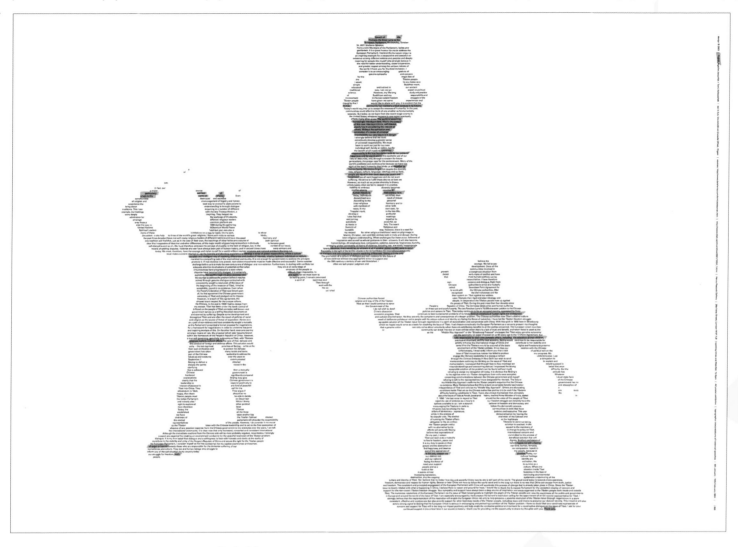

Design: **FL@33**
Country: **UK**

Dalai Lama

Along with 39 other designers and studios, FL@33 was asked by the Henry Peacock Gallery in London and Grafik magazine to create a typographic interpretation of a historical speech for their contribution to the poster exhibit "Public Address System." This poster interprets a speech given by the Dalai Lama to the European Parliament that talked about universal responsibility, explaining that if we all were less selfish we could avoid war. "Our initial idea was to have an illustration of 70 to 80 toy soldiers from various centuries," explains Tomi Vollauschek. "Then we decided to select only three figures. The top one is a Neanderthal guy, the next a Viking, and the last a contemporary soldier. These figures represent phases in human history. We also had this classic Tarantino Reservoir Dogs image in mind, where everybody is pointing a weapon at each other and everybody could die at the same time."

The entire speech is reprinted in the shape of the figures, with the important sentences highlighted in orange. Univers 55 has been used in a small 5pt type size to encourage the viewer to step closer and explore the text, but the highlights help to get the main message across. The poster was printed in black and fluorescent orange in a limited run of only 300.

Stereohype

This poster was created for the sister company of FL@33, Stereohype.com, an online graphic-art and fashion boutique. It offers limited editions and rare products, focusing on fresh, innovative, and inspirational works as well as exclusively commissioned artworks.

The artwork features the Stereohype logo, with its custom-made typeface combined with an additional hand-drawn font. The color gradient was deliberately chosen to communicate the growing and vibrant collection of designer goodies available at the site. The squirrel motif is part of the visual language developed by FL@33 for the company.

For budgetary reasons the artwork was printed in CMYK only; however, an alternative version, featuring silver and blue reflective stock, was created for a cover of Novum magazine.

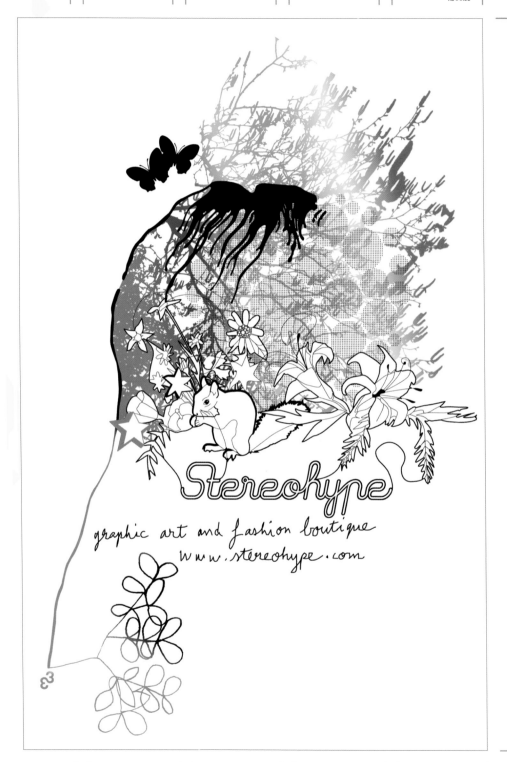

Periodic Table of British Elements[05]*

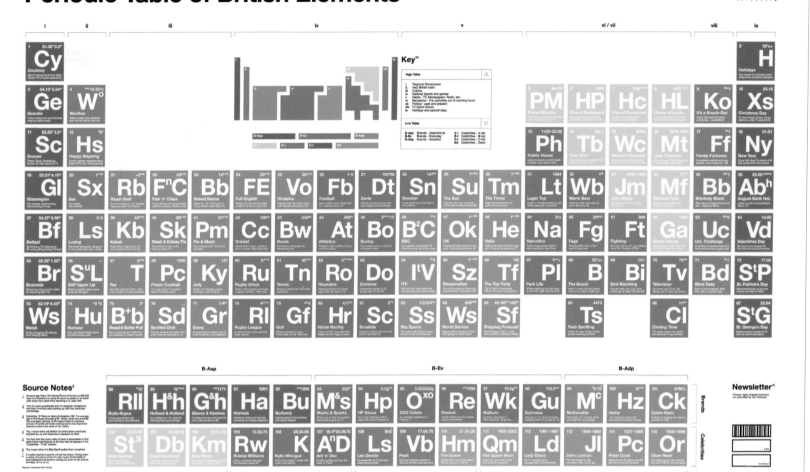

Design: **Tom Rothwell**
Country: **UK**

Periodic Table of British Elements

With this self-promotional mailer, Rothwell wanted to deconstruct British culture in an amusing and easy-to-digest way. Inspired by the many and varied characteristics of British culture, Rothwell explains, "The periodic table was a perfect structure to use, because it's split up into distinct sections, and, although they house many disparate elements, they are linked together by their very nature." It has been printed using seven fluorescent colors, along with black and gold for the Queen and her mother.

The poster was printed on A1 (23⅜ x 33⅛in/594 x 841mm), gloss-white PVC to give it a clinical feel.

Design: **Sweden Graphics**
Country: **Sweden**

Oddjob

This poster was created by Swedish designers Sweden Graphics as part of the marketing campaign around a music CD release by jazz band Oddjob, titled <u>Koyo</u>. Following on from the design used on the CD cover—also designed by Sweden Graphics—this poster was used for point-of-sales in record stores and to promote live concerts by the band.

The CD cover features the same Oddjob logo as you see on the poster here. It was created by Nille Svensson, designer at Sweden Graphics, and Anders Jacobsen at craft designers La`gombra. They took the 2-D logo and made it into a 3-D object using wood.

"Jacobsen made it using scrap material, mostly plywood and hardboard," explains Svensson. "I thought that playing around in this way with the form of the logo would be fun," he adds. "I worked with Jacobsen on it, as he is a designer and craftsman whose work I really admire."

The logo is filled with expanding foam so it can't collapse under its own weight, and a support beam has been added to help it to stand upright.

The background imagery of the poster is of building-board material that Svensson found, with some additional Photoshop brush red.

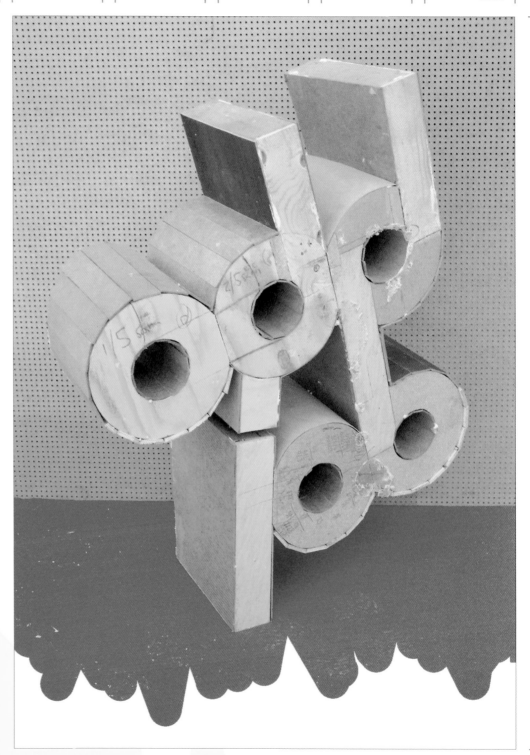

Design: **Unfolded with Julie Joliat**
Country: **Switzerland**

IT-Pool

This poster was created by Swiss design studio Unfolded together with graphic designer Julie Joliat to promote a series of computer courses at the Zurich School of Art and Design.

"As the courses were all about computer skills, we designed one side of the poster using only the computer and the other side completely by hand," explains Friedrich-Wilhelm Graf of Unfolded. "The idea was to show what can be done with computers and what can be done without. It was also a test for us, to feel how people used to work before computers. Making things by hand can bring results that you would never be able to achieve with the computer, and vice versa."

The choice of paper stock continues this theme, as the designers printed on a stock that has one glossy side and one uncoated side.

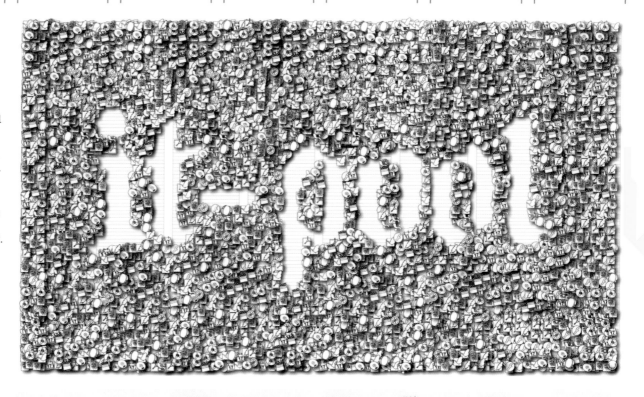

Design: **Ralph Schraivogel**
Country: **Switzerland**

Out of Print

Created by Ralph Schraivogel for the Museum of Design in Zurich, this poster was produced to promote an exhibit there titled "Out of Print." Schraivogel was not briefed as such, so, inspired by the title of the show, he came up with a poster that shows, quite literally, what happens when you run out of print, or printing inks. The title appears in full at the top of the poster, but the text increasingly fades away on the right-hand side of the page the farther down you go.

It was silkscreened in monocolor with a spot varnish on the red spots to give it depth. It was displayed in the museum and throughout Switzerland.

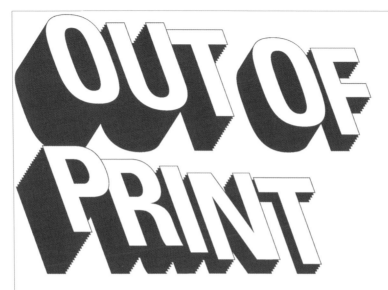

Design: **Studio Oscar**
Country: **UK**

Loop

Club Loop, in Shibuya, Tokyo, has played host to many mainstream international DJs, including Louie Vega and Maurice Fulton. To celebrate its eighth anniversary, Oscar Wilson at Studio Oscar was commissioned to "design an image promoting peace and love to accompany a commemorative calendar."

Inspired by 1960s British Pop Art, the main typographic image on the poster he created is a visual play on the club's name—Loop—incorporating a number 8 in place of the two Os. The dove symbol, which represents the peace aspect of the brief, and the Yellow Submarine-esque swirls in the artwork were hand-drawn, then scalpel-cut from ruby-lith film.

The poster was printed as a lithographic reproduction on a coated stock and displayed in record shops and cafés around Tokyo. A limited-edition T-shirt was also produced.

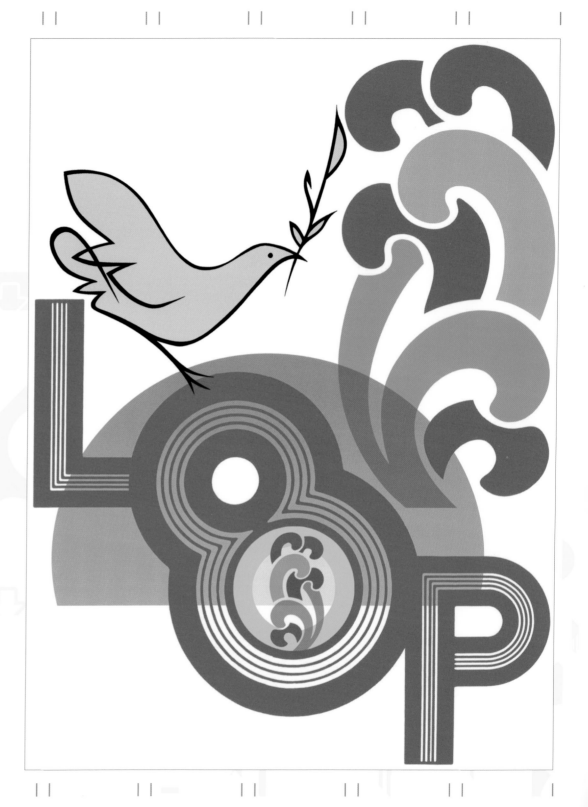

Design: **Gustavo Lacerda**
Country: **The Netherlands**

Multiculturalism Now

As part of Gustavo Lacerda's studies, he was asked to interpret the theme "Multiculturalism in the Netherlands now." He has used typography in the style of Trouw, a well-known newspaper from The Hague, to display the statement, "Multiculturalism is an attempt to preserve a cultural identity, something that by definition is impossible to preserve." This sentence is printed in full twice at the top of the poster. The first sees it printed in Swift, a font from Gerard Unger designed to be used in newspapers. Lacerda chose Swift for its contemporary nature, and because it is representative of modern Dutch type design. The sentence was cut from paper and pasted on the upper part of the film. Lacerda then copied this line by hand using a marker on the film. The first repetition is complete, but after that it becomes less and less complete, and less and less readable.

"To write on film in a marker meant it was definitive," he explains. "What was written could not be erased, and all the mistakes or characteristics done in a previous sentence had to be copied and carried through to the following sentence. In addition, all the work was carried out standing, with the film attached to a wall, and all the work had to be done in one day, with few breaks." The end result is a poster that in a sense runs to a grid and conforms to a certain system, but eventually collapses and fades away. This creates the perfect metaphor for the idea of the impossibility of preservation, as written in the statement.

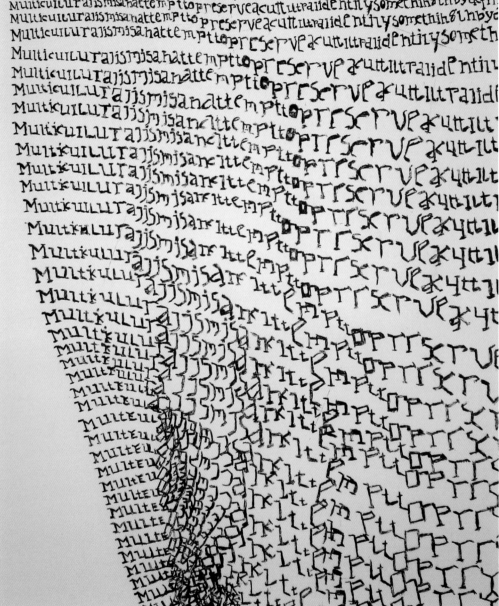

Design: **Blam**
Country: **UK**

I Spy Graphics

This print was created by London-based designer Mark Blamire at Blam for an art exhibit called "I Spy Graphics." The brief for all the designers who took part was to respond visually to the phrase, "I Spy With My Little Eye" with something that had inspired them in the preceding 24 hours. The overall aim of "I Spy" was to profile graphic design as a valuable art form and to offer designers an opportunity to use their creative skills outside the commercial domain.

Inspired by letters on his son's bedroom door, Blamire created a poster that contains no vowels. "My son Jack has his name on his bedroom door in wooden letters, and he pulled the letter 'A' off, but I liked the way it still said his name, 'JCK,'" he explains. "When I thought about it, it tickled me that you have the ability to say 'FCKFF' to someone—sorry, I do like swearing—without the use of VWLS."

Set in Helvetica Neue 75 Bold, the poster is, in short, a diagram illustrating how the English soccer league tables were at the end of the 2005–2006 season. The poster also formed part of an exhibit curated by online gallery Blanka as part of the London Design Festival 2006. Titled "1—An Exhibition in Mono," it featured the work of 28 designers who have all produced A1-sized (23⅜ x 33⅛in/594 x 841mm) black-and-white posters.

Design: **Alexandre Bettler**
Country: **UK**

The Rivers of Nothing

This poster was a self-initiated piece created by Alexandre Bettler while studying at the Royal College of Art in London. As Bettler, who wrote the text, explains, it is "making a connection between the different moments of Nothing that we can experience, while speaking, writing, or reading. It is expressed visually here as a text containing a river, the nice name for a blank line running through a text that graphic designers should avoid. On the poster the river goes from top left to bottom right."

Bettler set the text in Calvert, one of the official typefaces of the college, which was inspired by Margaret Calvert, a former head of the Communication Art and Design course.

The poster was silkscreened in black on a heavy paper stock. A limited run of 15 was produced.

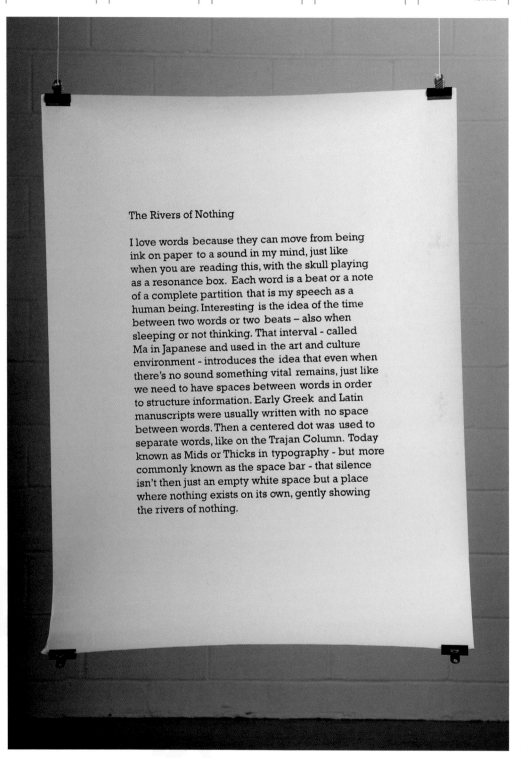

Design: **Jonathan Ellery at Browns**
Country: **UK**

A Beautiful Catastrophe

When Magnum photographer Bruce Gilden published a book about his home town of New York in 2005, designer and friend Jonathan Ellery created this series of posters to promote its release. Titled A Beautiful Catastrophe, after Swiss architect Le Corbusier's comment about New York, "A hundred times have I thought New York is a catastrophe, and fifty times, it is a beautiful catastrophe," the book features images by Gilden that capture the characters and eccentricities of the city.

For the posters Ellery decided against using photography and went instead for a purely typographic solution. Continuing the theme of comments about New York from the title, he has used quotes from famous New Yorkers to try to evoke the claustrophobia, passion, architecture, energy, and threat of violence that can be felt or found in the city.

Each poster has been printed one-color, black, on uncoated paper.

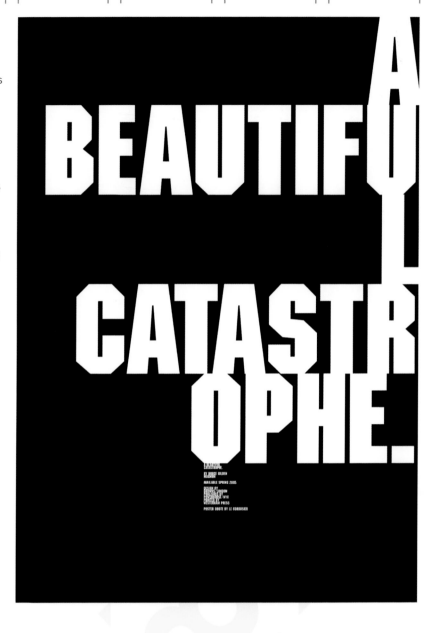

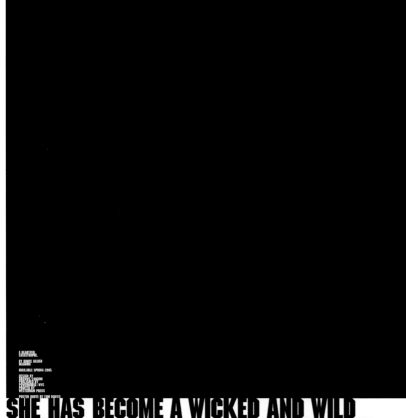

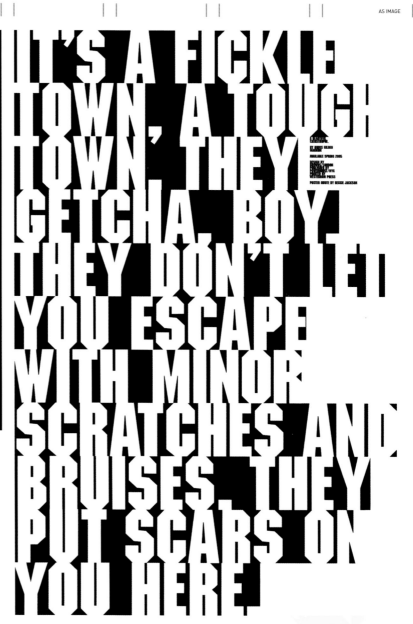

A BEAUTIFUL
CATASTROPHE.

BY BRUCE GILDEN
ALADDIN

AVAILABLE SPRING 2005

DESIGN BY
RENZO & GONDOM
CHELSEA / NYC
SECAUCUS / NYC
WESTERMAN PRESS

POSTER QUOTE BY TOM DAVIS

SHE HAS BECOME A WICKED AND WILD
BITCH IN HER OLD AGE HAS MANHATTAN,
BUT THERE IS STILL NO SENSATION
IN THE WORLD QUITE LIKE WALKING HER
SIDEWALKS. GREAT SURGES OF ENERGY
SWEEP ALL AROUND YOU; THE AIR FIZZES
LIKE CHAMPAGNE. WHILE ALWAYS THERE IS
A NERVOUS EDGE OF FEAR AND WHISPERED
DISTANT PROMISES OF SUDDEN VIOLENCE.

A BEAUTIFUL
CATASTROPHE.

BY BRUCE GILDEN
ALADDIN

AVAILABLE SPRING 2005

DESIGN BY
RENZO & GONDOM
CHELSEA / NYC
SECAUCUS / NYC
WESTERMAN PRESS

POSTER QUOTE BY REGGIE JACKSON

IT'S A FICKLE
TOWN, A TOUGH
TOWN, THEY
GETCHA BOY
THEY DON'T LET
YOU ESCAPE
WITH MINOR
SCRATCHES AND
BRUISES, THEY
PUT SCARS ON
YOU HERE

Design: **CHK Design**
Country: **UK**

John Cage

This poster was created by Christian Küsters at CHK Design for the poster exhibit "Public Address System" at the Henry Peacock Gallery in London. The gallery invited 39 designers to create a poster based on a quotation of their choice. "I chose a John Cage quote which I thought was appropriate for my work," explains Küsters. "The actual poster was a 3-D object consisting of two layers: the back layer with the quote and the front layer on glass with lines. The top layer was completely transparent, so the reader can either focus on the quote below, or the lines above. One layer would always be blurred."

The AF Carplates typeface—the most common font used on UK car license plates— was used as Küsters felt this related well to Cage's words.

THE HISTORY OF ART IS SIMPLY A HISTORY OF GETTING RID OF THE UGLY BY ENTERING INTO IT, AND USING IT. AFTER ALL THE NOTION OF SOMETHING OUTSIDE OF US BEING UGLY IS NOT OUTSIDE OF US BUT INSIDE OF US, AND THAT'S WHY I KEEP REITERATING THAT WE ARE WORKING WITH OUR MINDS. WHAT WE ARE TRYING TO DO IS TO GET THEM OPEN SO THAT WE DO NOT SEE THINGS AS BEING UGLY OR BEAUTIFUL BUT WE SEE THEM JUST AS THEY ARE. JOHN CAGE

Design: **Daphne Heemskerk**
Country: **The Netherlands**

Multiculturalism Now

This poster was designed by Daphne Heemskerk while studying for an MA in Graphic Design at AKV/St. Joost in Breda, in the Netherlands. The brief was to design a poster about multiculturalism in the Netherlands today.

"Multiculturalism means that people live in a society with different ethnic backgrounds, their own religions, own language, values, and standards," says Heemskerk. To this end, she has used typography to interpret her brief by creating a typeface that merges two cultures. This has been executed by setting the text in a hand-drawn typeface that begins in English, and then evolves into Arabic. "The whole process is hand-craft," she explains. "The typography is handmade, the letters are drawn by pencil, and then each letter has been cut out of black paper and stuck by hand onto the film before printing."

It is a simple, clever way of interpreting the brief with the seamless transition from English to Arabic, providing a really great example of the versatility of type.

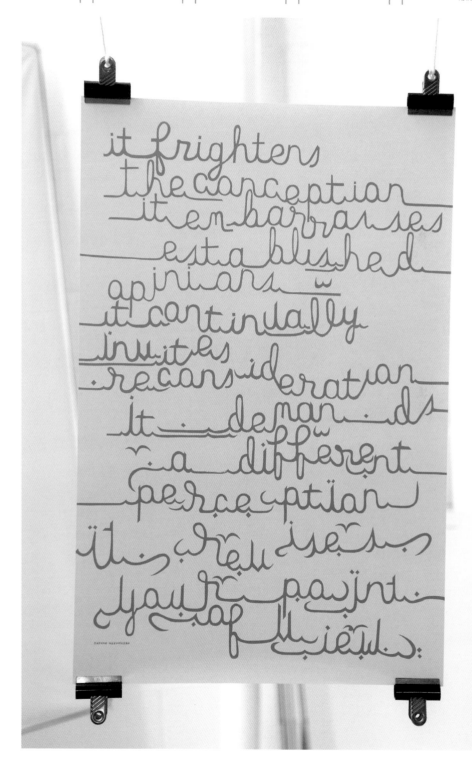

Design: **Form**
Country: **UK**

Re:Creation

This series of posters was designed for Re:Creation, an award scheme organized by Dazed & Confused magazine and clothing chain Topshop. The scheme celebrates the best of a new crop of creative British talent in the fields of, among others, photography, design, illustration, and music production.

The awards were organized in conjunction with club nights in various towns and cities around the UK—including Leeds, Manchester, Glasgow, and Brighton—so the posters were designed to publicize the call for entries for the awards as well as to advertise the fact that Re:Creation had come to a given town that night.

"Our brief was to design something that was fairly abstract and nonspecific," explains Paul West at Form. "So many areas of talent were being recognized, we didn't want the identity to feel like it belonged to one area over another."

The solution was to create an identity that felt quite leftfield. "We liked the idea of stacking the typeface and adding the drop shadow so that we could flood different textures and shapes in a very 2-D, lo-fi kind of way," adds West. "It seemed to represent the spirit of the occasion perfectly."

Designed by West and Nick Hard, the posters were displayed around the cities in which the club nights took place, and featured as ads in Dazed & Confused.

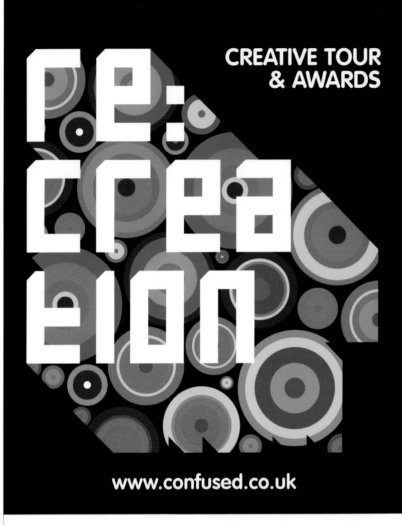

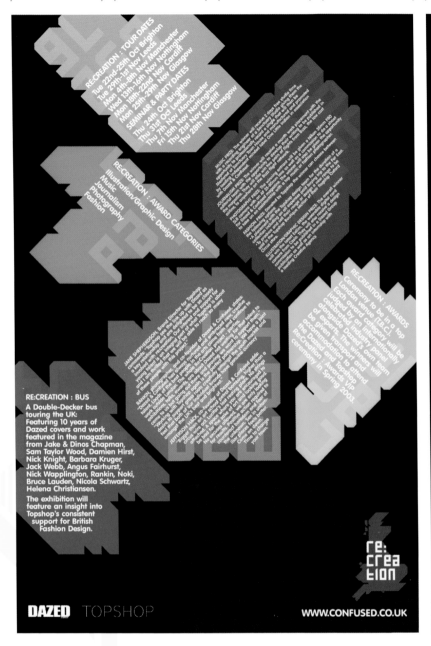

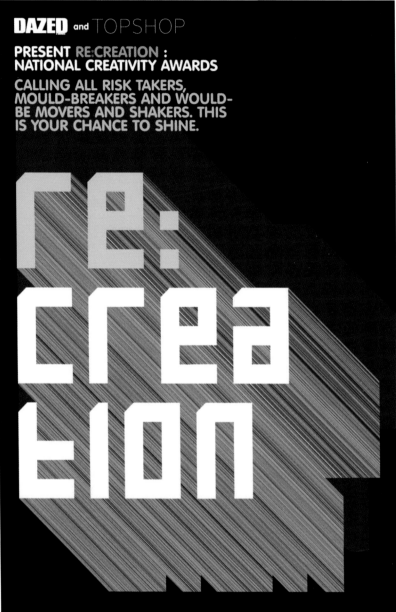

Design: **Dipesh Pandya**
Country: **France**

Playlist

This poster was created by Dipesh Pandya for a contemporary-art exhibit held at the Palais de Tokyo, Paris. The design is rooted in the theme of the exhibit and in the work of the featured artists, all of whom use popular cultural icons or objects in their art. Those artists included Bertrand Lavier, Cercle Ramo Nash, Dave Muller, Samon Takahashi, and Carol Bove.

To this end Pandya has used the folder icons found on Apple Macintosh computers to create the typeface and other visual elements on the poster. "I really wanted to translate the idea of the exhibit," explains Pandya. "I was inspired by the older Macintosh operating system and the state of my computer desktop. I wanted to recreate a sort of visual 'mess,' but at the same time give it structure, so the Macintosh graphic elements were used to create the effect of layers of information and to make individual letters that formed the title."

The folders in the center of the poster form the word "Playlist" destructured, and those at the bottom represent other "objects, icons, concepts" ready to be used to create new forms and artworks. The design of the poster was part of the graphic identity of the exhibit, which also carried through to the catalog that Pandya designed. The typeface used for the names of the featured artists to the right of the poster is UNDA Vertical.

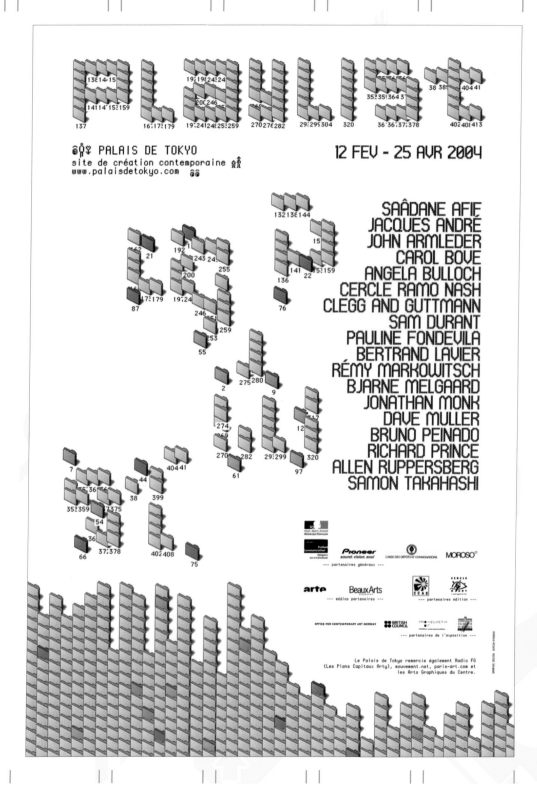

Design: **LAKI 139**
Country: **UK**

Marriage of RBMA & JSK

This one-off poster was a wedding
present designed by Simon Slater (best
man for the groom) at LAKI 139.

"My first objective was to create a logo
with the couple's initials 'RBMA' and
'JSK'. I wanted to mix an Arabic style with
a traditional English style." The letters
were drawn with a calligraphy pen then
scanned in and made into vector art. The
strokes from the R, M, A, and K were
loosely based on a Lily, the bride's
favorite flower. These strokes lead the eye
to the date of the marriage, set at the top
of the poster. Vector art flourishes were
added for depth and movement. The
best-man's speech was added to the foot
of the poster.

The paper stock used was newspaper
print. When exposed to sunlight, this
stock ages and bleaches giving a vintage
feel to the artwork. The final artwork was
window-mounted into a dark wood frame.

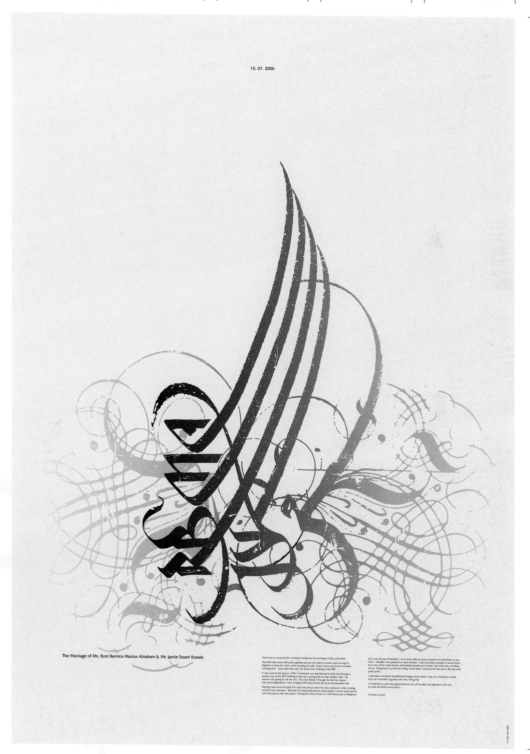

ART DIRECTORS CLUB NEW YORK EXHIBITION ON BROADWAY*

***IN SYDNEY**
83RD ANNUAL AWARDS: CELEBRATING CREATIVE EXCELLENCE IN ADVERTISING, DESIGN, PUBLISHING, PHOTOGRAPHY, ILLUSTRATION, FILM, VIDEO AND INTERACTIVE MEDIA.
12 APRIL -6 MAY 2005. UTS GALLERY, LEVEL 4, 702 HARRIS ST. OFF BROADWAY, ULTIMO, SYDNEY
T: 9514 1652 F: 9514 1228 E: UTSGALLERY@UTS.EDU.AU WWW.UTSGALLERY.UTS.EDU.AU
TUES-FRI 12-6PM
SUPPORTED BY: UTS FACULTY OF DESIGN, ARCHITECTURE & BUILDING
UTS MARKETING & COMMUNICATIONS

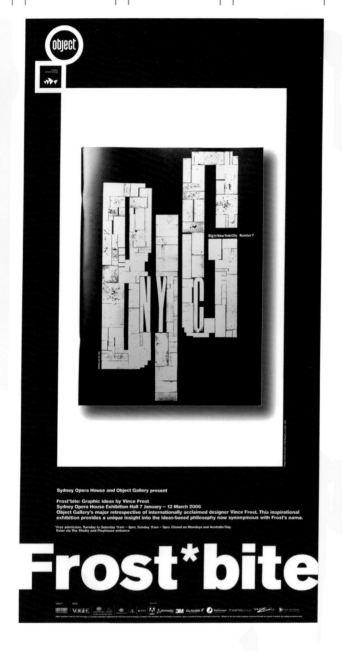

Design: **Frost Design**
Country: **Australia**

ADCNY

Frost Design in Sydney, Australia, created the ADCNY (Art Directors Club New York) poster to promote the organization's traveling exhibit. "We found a link between the New York and Sydney exhibition venue locations with both being on Broadway," explains Vince Frost. Typography in the style of a Broadway theater poster has been printed in black ink on white paper. Displayed around Sydney, it is a great example of a straightforward, highly effective piece.

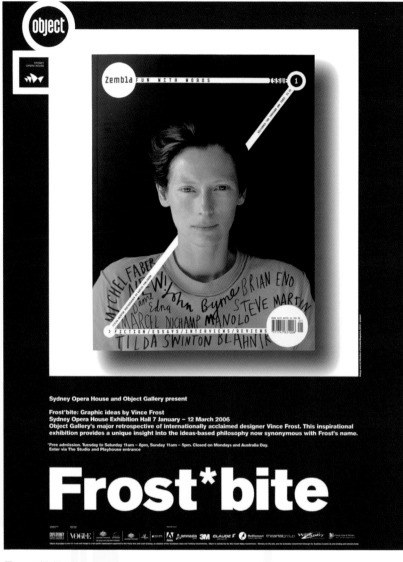

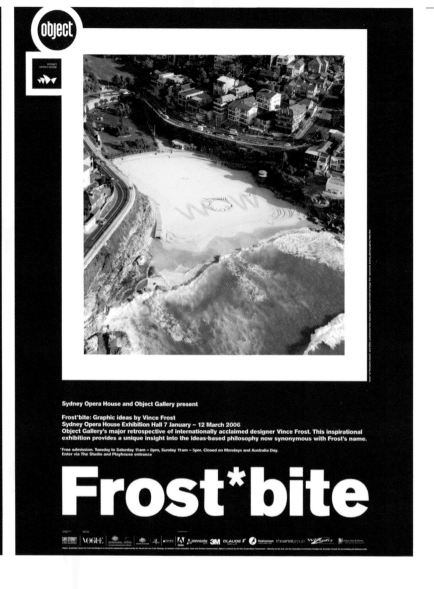

Frost*bite

The Frost*bite series was created for an exhibit by Frost Design held in the Object Gallery at the Sydney Opera House. Again, this is trademark Frost design, with bold use of Akzidenz Grotesk Super, the font used by Frost for all the company's identity materials. All of the posters shown here were designed by Vince Frost and Anthony Donovan.

As Text

"Only a witty and risky manner of dealing with the subject makes the design unique."

Philippe Apeloig, Studio Apeloig, France

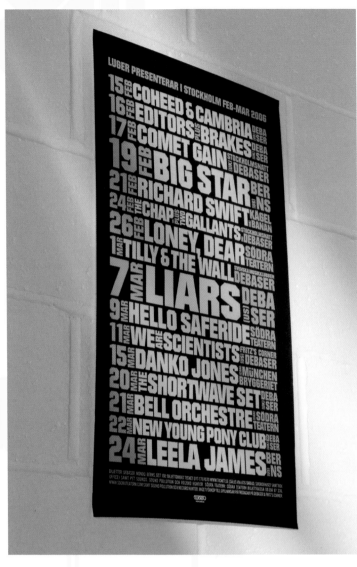

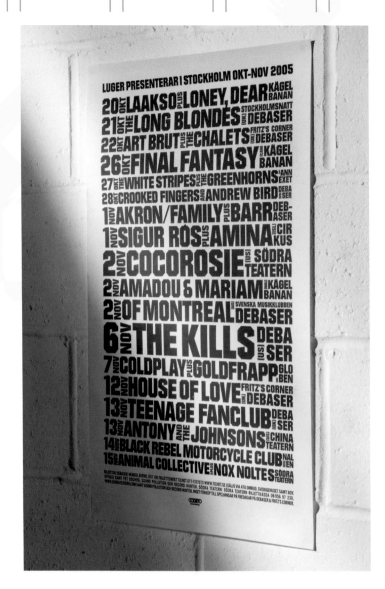

Design: **Henrik Walse**
at **Walse Custom Design**
Country: **Sweden**

Luger

These two posters were created for Luger, a concert-booking agency in Stockholm. They are both great examples of how designers can use simple, bold typography to communicate a message clearly to a given audience. The typeface used on both posters is Diamond, set in a variety of point sizes, with the acts and venues set horizontally and the months vertically. The use of an uncoated stock and fluorescent inks on one poster and simple off-black on off-white on the other make for a pair of classic posters, the design of which, says Walse, was inspired by the work of US typographer Herb Lubalin. The posters were displayed around Stockholm.

Design: **Uwe Loesch**
Country: **Germany**

Körpersprache/
Ben Oyne/A Bientôt

These three posters were designed by
Uwe Loesch. The first, Körpersprache,
was created in 2003, jointly for the
Museum of Arts and Design New York,
the Museum for Applied Art in Frankfurt,
and the Klingspor Museum, Offenbach,
Germany. "The idea for the typography on
the poster was to make it look like it is
turning on its own axis," explains Loesch.
"But at the same time it should look like
a sculpture, with the English words
crossing over the German words."

The second poster was designed to
promote a lecture by photographer and
director Ben Oyne at the University of
Wuppertal. Inspired by Oyne's profession,
Loesch's idea was to have the typography
take on the form of the focus function
on a camera. The poster features seven
different typefaces, designed specially
for the poster, and called Focus One,
Focus Two, and Three, Four, Five, Six,
and Seven. It was silkscreen printed.

The third poster features the famous
New Alphabet typeface, created by Dutch
typographer Wim Crouwel in the 1960s.
Designed by Loesch for the Centre Culturel
de l'Agdal, Rabat, Morocco, it features text
in Arabic and French and uses color that
references the Moroccan flag. It was
displayed on the streets of Rabat.

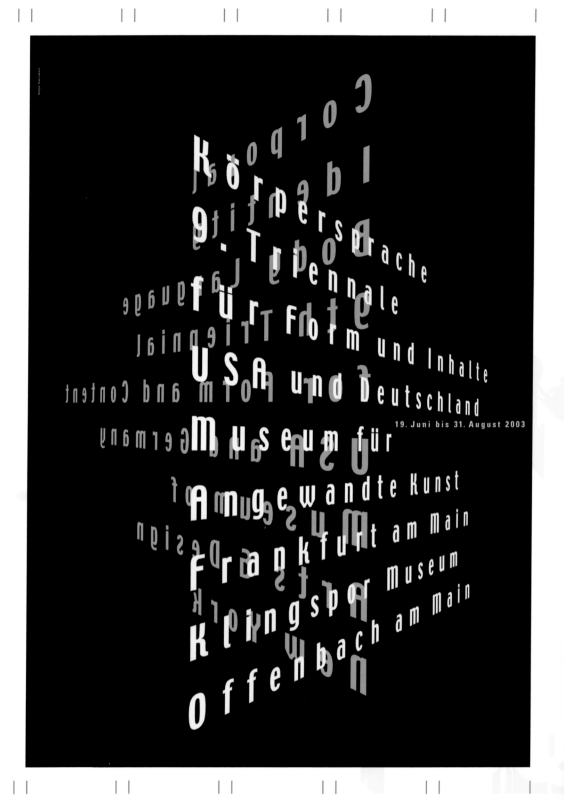

Ran Dyne

Fotograf und Filmemacher

28. Juni 2002 von 10 bis 16 Uhr

Vortrag Präsentation Diskussion

Bergische Universität Wuppertal

Ecke Haspeler Straße 27

in der Aula

Gestaltung: Uwe Loesch

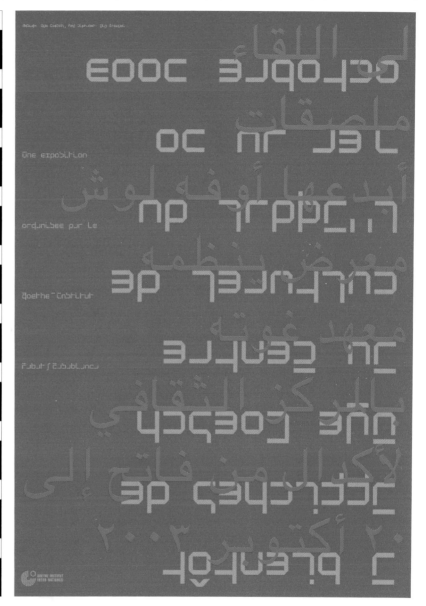

Design: **Andreas Emenius**
Country: **Denmark**

New Speed

This poster was created to promote a
day-long Scandinavian electronic music
festival held in London in 2003. It was
designed by Copenhagen-based Andreas
Emenius, who was asked to create
something low-key, but striking, that
had an electronic feel, and hinted at the
musicians' countries of origin.

"We wanted something slightly quirky,
a bit boring, so to speak, but with an
underlying feel of power and self-
confidence," explains Emenius. "We
decided on a photographic approach, and
made a poster within a poster." To do this,
Emenius created a typographic poster on
a yellow stock that "hangs" on a plain
wall over electronic cables.

The typeface used is FFTheSerif which
was handset on the back of a train
timetable poster for the Copenhagen
railway. If you look closely, you can see
part of the timetable coming through.

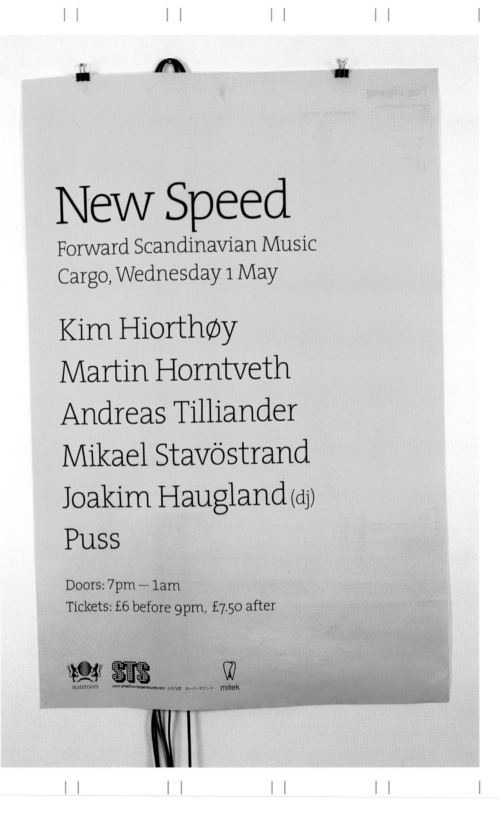

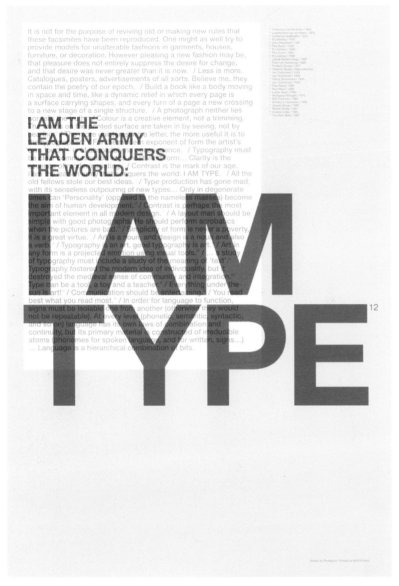

**This is
a poster.**

__Primarily it serves the purpose
of promoting a lecture on graphic
design by Angus Hyland at the
Exeter Faculty of Arts, University
of Plymouth on Friday April 28th,
2006 at 1.30pm.
__Subsequently this poster can
become a memento of the event,
an object of desire in its own right,
or it can simply be disposed of.
__Furthermore, it fulfils an
egocentric objective to be entered
into design competitions.

Design: **Pentagram**
Country: **UK**

I Am Type/This Is a Poster

These two posters were created by
Angus Hyland, partner at London-based
Pentagram. I Am Type was created by
Angus Hyland and Charlie Hanson for
"Public Address System," an exhibit of
posters, each bearing a typographically
interpreted speech or quote, held at the
Henry Peacock Gallery in London.
Hyland based his poster on 27 quotes
by famous typographers and designers,
including El Lissitzky, Paul Rand,
Jan Tschichold, and Neville Brody. The
quotes are set in a warm, gray sans-
serif type on a white background. The
main focus is a quote by Frédéric Goudy,
"I am the leaden army that conquers
the world. I am type," which is set in a
larger point size across the other
quotes, giving this poster a real sense
of energy.

For This Is a Poster, Hyland was assisted
by Fabian Herrmann. Typeset in Berthold
Akzidenz Grotesk, the poster was
silkscreened in black and white on 25
different shades of Colorset 120gsm
paper. Production was limited to four
copies per shade.

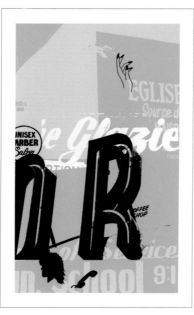

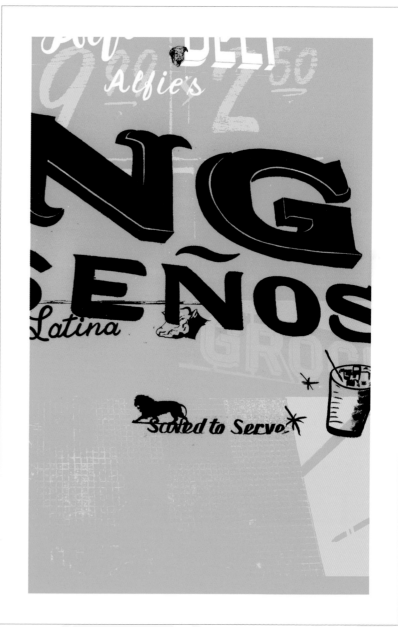

Design: **Stereo Type Haus**
Country: **USA**

Self-promotional

This self-promotional series was designed by Rick Diaz Granados at Stereo Type Haus. "I'd been taking pictures of hand-painted signage for over two years, and wanted to use them as inspiration and a basis for a collage, a sort of loose, abstract study of the shapes," he explains. "It was just a personal way for me to get out of the box, to have fun, and get more into a fine-art mode and away from rigid client concerns."

The images used to create the posters came from photographs shot in New York, Los Angeles, and Miami.

Design: **Fernando Gutiérrez at Pentagram**
Design Assistant: **Susan Jamieson**
Country: **UK**

Hermés

This was a call-for-entries poster for an annual student competition to design a window display for Hermés. The theme was El Río Punto de Conexión de las Diferentes Culturas, roughly translated, The River as a Meeting Point for Different Cultures. The brief for the students was to create an installation for display in a window at the Hermés flagship store in Paris, where passers-by would be engaged and inspired by the subject matter and execution.

The poster is a striking one. The vibrant orange ground is an attention-grabber, and complements the typographic imagery that relays this year's theme to the student. The word Río—river—is split in two, the course of the river defined by the gaps between the letters. The image is a symbol, suggesting to the students that they should consider the way in which a river links people and cultures, and how it acts as a channel for the dispersal and sharing of knowledge, resources and produce, etc.

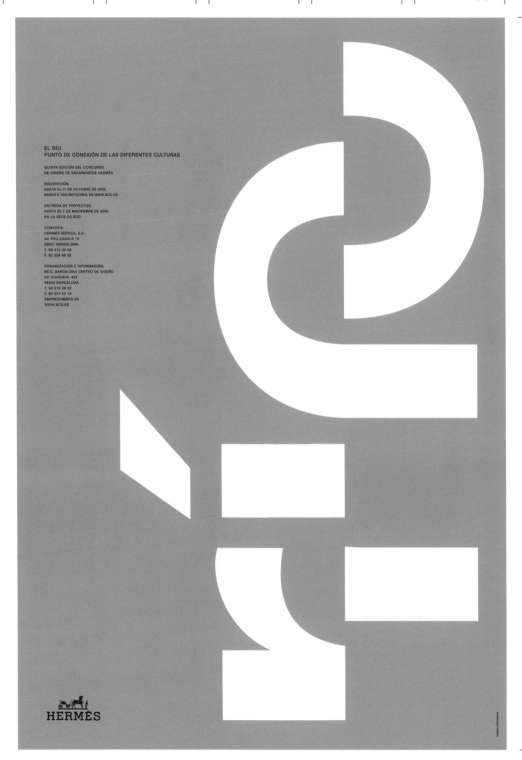

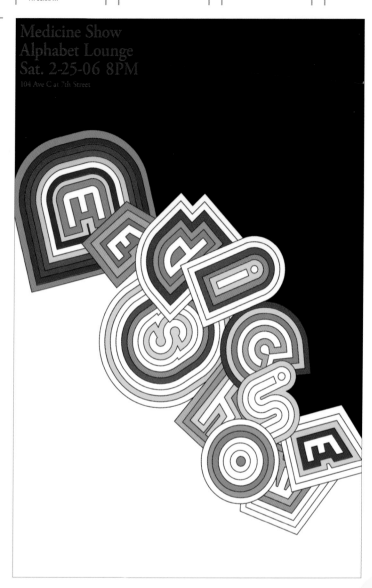

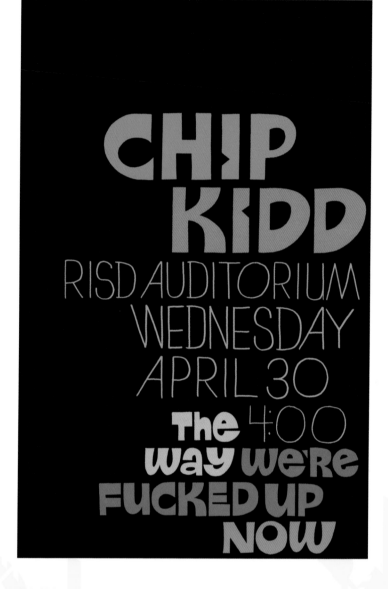

Design: **Joe Marianek**
Country: **USA**

Medicine Show/Chip Kidd

The first poster advertised a show by the band The Medicine Show. The brief was to create a poster that was evocative of the abstract, gritty, electronic "music" that the band generates. Inspired by Milton Glaser's famous poster of Bob Dylan in profile and with psychedelic hair, Marianek has created a poster that, as he says, "looks like a bad acid trip. The idea is perfect for The Medicine Show, because that's how the band sounds."

Chip Kidd was created for the Rhode Island School of Design, Department of Graphic Design, to publicize a lecture by designer Chip Kidd about his work "The Way We're Fucked Up Now." "It seemed like a good idea to feature his name prominently, because it is memorable and iconic," explains Marianek. "The title of the lecture was so totalitarian and ominous that it necessitated the use of happy elements to react against." The color palette was inspired by Kidd's own work, which often makes use of bright pop-art colors, and the hand-lettering is from a children's alphabet book.

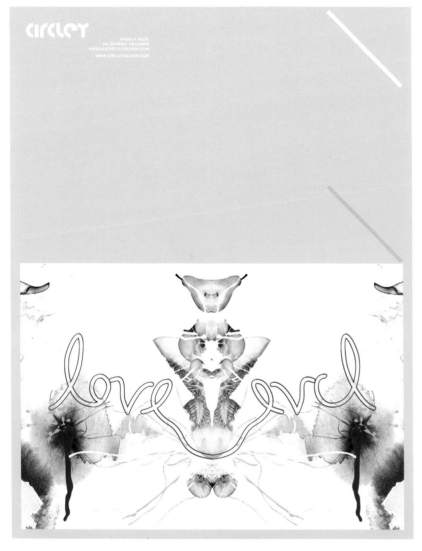

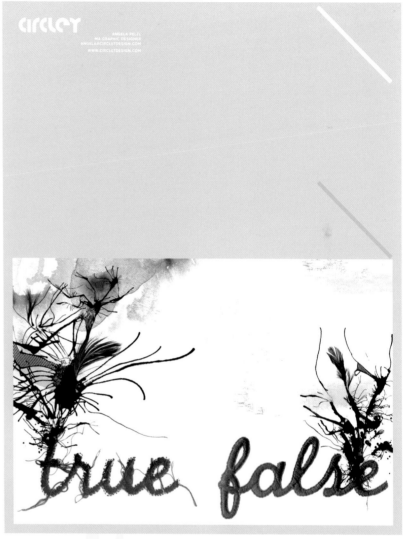

Design: **Angela Pelzl at Circlet**
Country: **Germany**

Circlet

These posters were a self-promotional project for friends and clients of German designer Angela Pelzl and her company Circlet. "I wanted to promote my graphic and illustrative design skills," she says, "and I wanted to have some fun!" To this end, Pelzl has experimented with black ink, watercolors, thread, and fruits. "For the images I used the vertical center axis to confront opposite keywords and mirror some of the design elements," she explains. "Ink currents created by blowing on the wet ink formed bizarre streams and branches. Fresh fruits were cut in slices and scanned in along with feathers that came loose from my sofa pillow." The typeface for "love—evil" was hand-drawn, while that for "true—false" was hand-stitched, using Monoline Script as a base.

Design: **Studio Apeloig**
Country: **France**

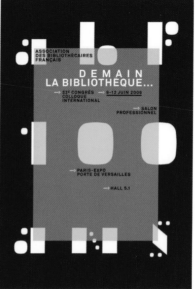

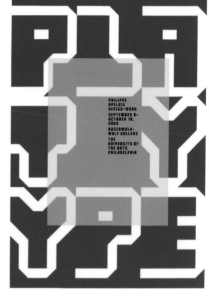

Châtelet

This first poster was for the Théâtre du Châtelet in Paris. The idea was to divide the word "châtelet" into three syllables displayed one on top of the other to create a memorable typographic image. "This design was made to emphasize a sense of musicality, as Châtelet is the main theater for music in Paris," explains designer Philippe Apeloig.

The en-dash that frames the second syllable has a musical connotation too; in musical notation the dash functions as the sign for a rest. The vibrant, neon-pink background gives the poster strong visual appeal, drawing attention to the start of a new season. This differs from the classic dark red that is traditionally used for communications for theater.

ABF

This poster was created to celebrate the centenary of the Association of French Librarians, the Association des Bibliothécaires Français (ABF). It was designed by Apeloig, who, at the same time, was commissioned to create a new logo and corporate identity for the ABF. "The idea of a library as a place to store information in books and printed matter will change," explains Apeloig. "More and more information is archived in electronic media, so the uniqueness of a library where people can sit and read was the inspiration for this poster."

To this end, the main concept for this design was to recreate an abstract view of a library floorplan, where different graphic elements refer to chairs, tables, shelves, and so on, while at the same time making the poster feel modern and of the digital age. The typeface used for the title is one designed by Apeloig himself, while for the body text he's used Akkurat. Arrows guide the viewer through the text on the poster.

Play Type

"Play Type" was an exhibit of Apeloig's work held at the University of the Arts, Philadelphia. For the exhibition poster, he used a typeface that he cut himself. "I usually use a personal exhibit as an opportunity to experiment with type," he explains. "Using typography can also be playful; it doesn't have to always be solely to inform and communicate."

All these posters are silkscreen printed in large scale. Apeloig explains, "I like to use traditional inks that are opaque and rich in pigment, because it means that the colors are extremely bright and powerful, and the visual impact is really strong."

Design: **Clea Simonsen** and **Heinrich Kreyenberg** at **Heutemorgen Büro für Gestaltung**
Country: **Germany**

Staatstheater Hannover

This was a promotional poster designed for three visiting plays at Staatstheater Hannover in Germany. "We were simply asked to present and list the titles, dates, and directors of the three plays," explains Simonsen. "We chose to use airport esthetics to suggest the anticipation and excitement that airports have, that special atmosphere of change, going somewhere, seeing off loved ones, or meeting someone." The typefaces used are Helvetica Neue and Gateway.

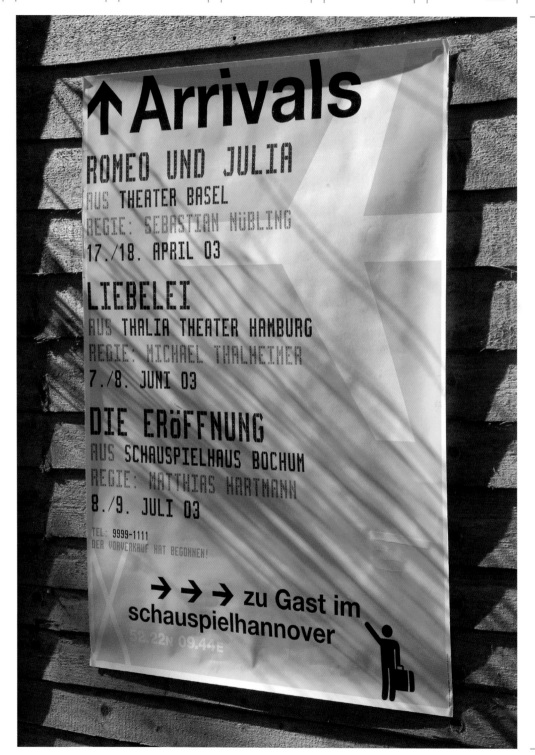

Design: **Studio Oscar**
Photography: **Scott Ford**
Country: **UK**

Juliette and the Licks

Inspired by 1960s American psychedelic-rock posters, London-based Oscar Wilson at Studio Oscar created this poster for the 2005 European tour of Juliette Lewis' band Juliette and the Licks. The main image used on the poster is a halftone version of an original black-and-white photograph taken by Scott Ford at one of Juliette Lewis' US appearances.

The "Juliette and the Licks" logotype at the top of the artwork was hand-drawn then scalpel-cut from ruby-lith film, and the tour dates and all other information on the poster are set in Helvetica Bold. "A red-and-blue color palette was chosen to be fairly 'clashing' and uneasy on the eye," explains Wilson.

The posters were printed using lithographic reproduction in two spot colors on a coated stock.

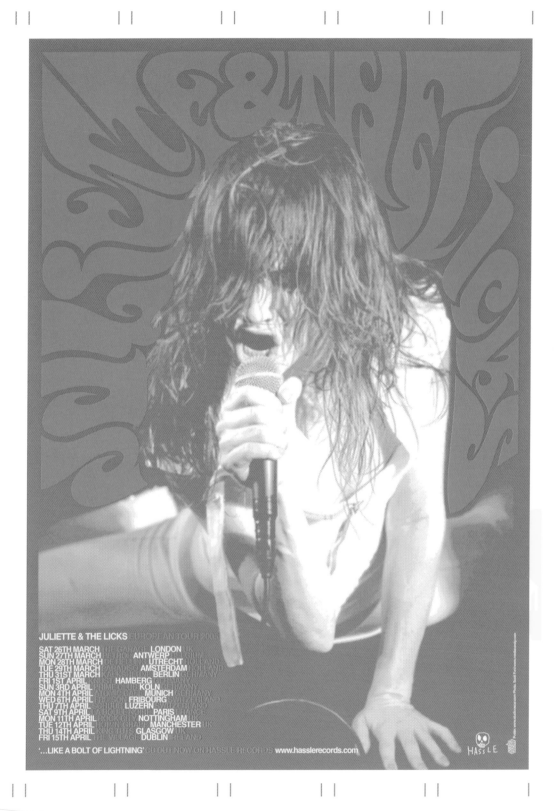

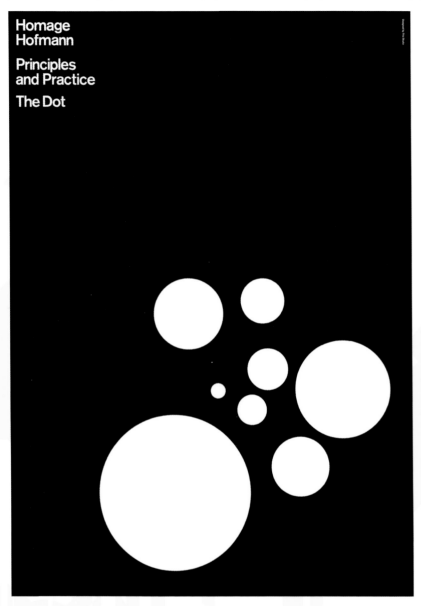

**Homage
Hofmann**

**Principles
and Practice**

The Dot

**Homage
Hofmann**

**Principles
and Practice**

The Line

Design: **David Bennett at This Studio**
Country: **UK**

Homage Hofmann:
Principles and Practice

David Bennett created these posters as self-promotional pieces. The concept behind this ongoing series is to remind designers that computers are only a tool to help them, and that they still need to know about the fundamental principles of graphic design, including dots, lines, type, and color. "The graphic elements on the posters are what I learned in college about how basic graphic design works," explains Bennett. "As its name suggests, this poster is a homage to Armin Hofmann [a Swiss graphic designer of the Basel School]. He was keen to explain how these elements work as the guiding principles to graphic design."

Design: **Dennis Eriksson at Woo Agentur**
Country: **Sweden**

Guided by Voices/ Hope Sandoval

Both posters were designed for Luger, a concert-booking agency in Stockholm, Sweden, and commissioned by Henrik Walse of Walse Custom Design.

Guided by Voices was designed for the band's 2002 Scandinavian tour. "I wanted a simple image and simple lettering, but with a weird and ugly feel," explains Eriksson. Printed in two colors on an uncoated stock, it is a great example of lo-fi design with its rough typography.

For Hope Sandoval Henrik Walse wanted Eriksson to create hand-drawn typography, stating, "Just letters, no images." He also wanted an old-school feel. The design was inspired by classic posters and ads from the late 1960s and early 1970s.

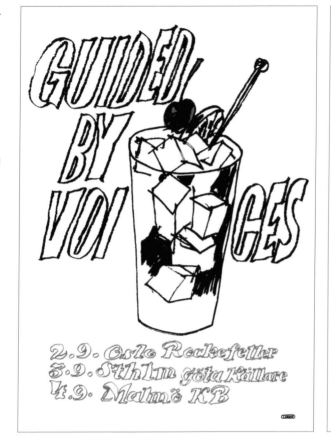

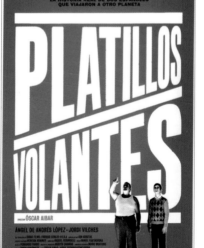

Design: **Fernando Gutiérrez at Pentagram**
Country: **UK**

Platillos Volantes

This poster was part of the promotional campaign for the movie Platillos Volantes (Flying Saucers). The movie is based around real-life events in Spain, when the bodies of two men were found bearing enigmatic notes concerning extraterrestrial activity.

The poster aimed to create a striking visual language, with large white type set in a dynamic fashion that references 1950s science-fiction movies and aims to suggest the speed of flying saucers. This theme was carried on through the campaign, which included a catalog, a T-shirt, and a Frisbee. Gutiérrez and Pentagram designer Chris Duggan also created the opening titles for the movie, using the strong B-movie-influenced typography that features here.

Design: **Hansje van Halem**
Country: **The Netherlands**

Geborduurd

This poster was designed to promote the "Geborduurd" ("Embroidered") exhibit at the Dutch Textile Museum in Tilburg, which aimed to show how embroidery is used as a conceptual design tool.

Inspired by a combination of old-fashioned vs. modern, and handcrafted vs. digital, van Halem began by creating a typeface that was painstakingly hand-drawn on a computer. "I used lines as thread, almost as if I was making stitches," she explains. "I tried to refer to embroidery without actually doing it. I also wanted the design to look high-tech and punky, even aggressive, but to soften it by using a light-pink background color."

The poster was printed in litho offset and silkscreen versions, and was also printed as a flyer, a booklet, and signage at the actual exhibit.

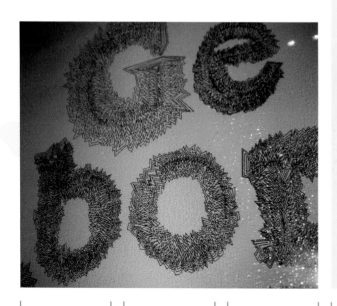

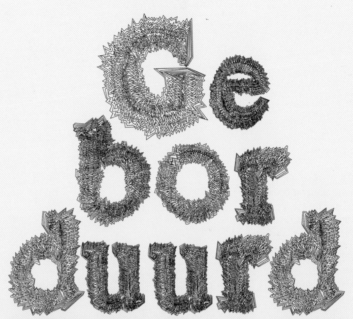

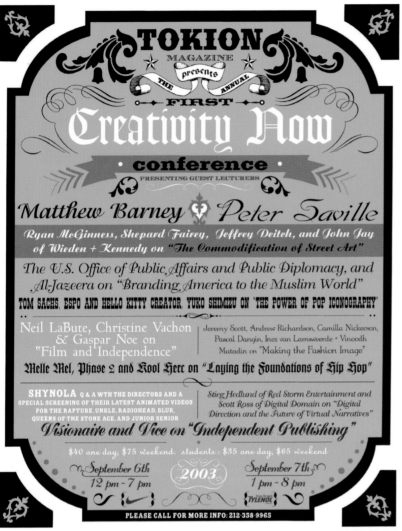

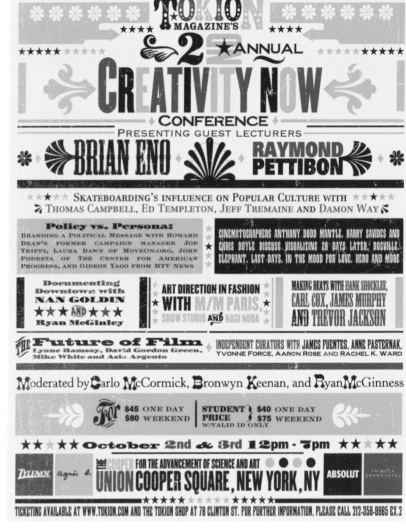

Design: **Chris Rubino**
Country: **USA**

Creativity Now

Every year since 2003, US magazine Tokion has produced and sponsored the Creativity Now Conference in New York City. Designer Chris Rubino has created the posters for all conferences to date. His brief is to advertise a long list of names on one poster in a creative fashion.

Inspired by woodblock prints, comics, and circus posters, Rubino has managed to create a series that is clear and informative despite the fact that each poster contains a large amount of text.

This has been achieved by using different typefaces for each piece of information, making it easy for viewers to distinguish between elements. Each element is complemented by a series of patterns and lines, and Rubino has chosen simple color palettes for each. "I've focused on designing an interesting image based mostly on typography," he explains.

The posters for the first and second conferences were both printed as limited-edition silkscreens and were displayed at the event. Creativity Now 3 was printed offset litho in large format and used as a street campaign all over Lower Manhattan.

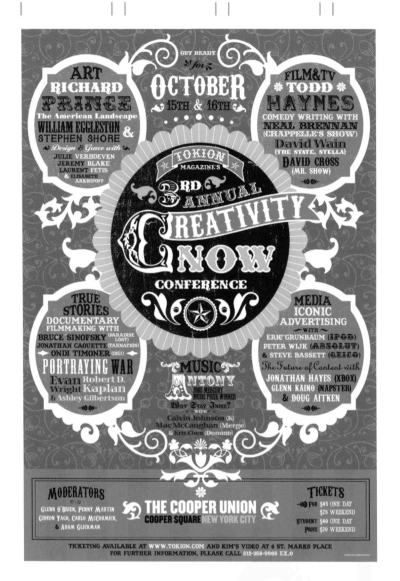

Design: **Gabor Palotai Design**
Country: **Sweden**

Scandinavian Design Beyond the Myth/Tekniska Museet

The concept for Palotai's design of this "Beyond the Myth" poster series was to use a single typeface—Berthold Akzidenz Grotesk—to symbolize the fact that Scandinavian design has moved on from what might be considered the clichés of 20th-century Nordic design. The pattern of typography has been "damaged," the idea being that the viewer looks through the text to discover the truth behind the clichés. For each country the exhibit visited, different colors were used—for example, pink for Berlin, gold for Milan.

The brief for the Tekniska Museet series was to create a graphic-design profile that promoted the museum itself as well as its exhibits. Palotai designed a typeface with soft-edged squares, inspired by the digital world, especially for the museum. Printed in two bold colors, the posters are simple, yet have real impact and depth.

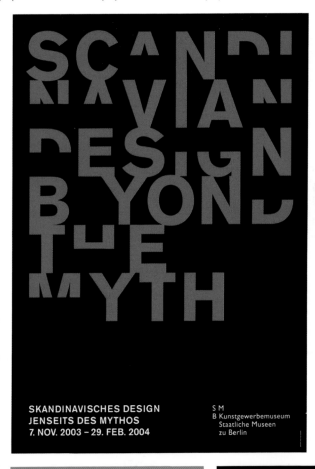

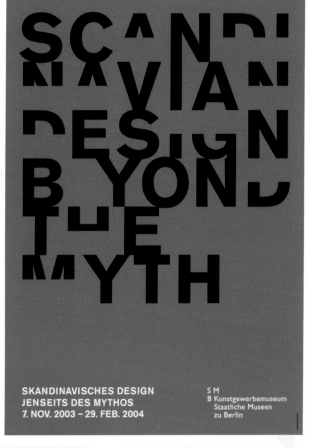

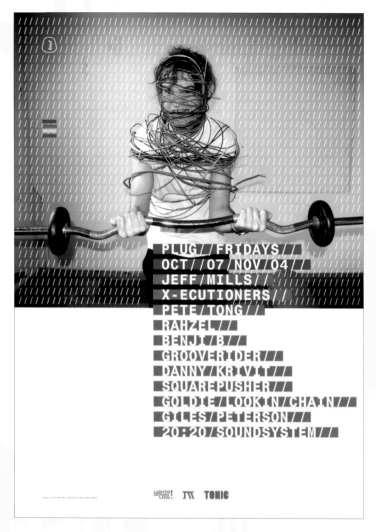

PLUG//FRIDAYS//
OCT//07/NOV/04/
JEFF/MILLS//
X-ECUTIONERS//
PETE/TONG//
RAHZEL//
BENJI/B//
GROOVERIDER//
DANNY/KRIVIT//
SQUAREPUSHER//
GOLDIE/LOOKIN/CHAIN//
GILLES/PETERSON//
20:20/SOUNDSYSTEM//

PLUG//FRIDAYS//
NOV/04//DEC/02//
WWW.THE-PLUG.COM
GILLES/PETERSON//
SQUAREPUSHER/LIVE//
MAMPI/SWIFT//
20:20/SOUNDSYSTEM/LIVE//
BRYAN/G//
GOLDIE/LOOKIN'/CHAIN/DJ/SET//
FC/KAHUNA//
LUKE/VIBERT//
SOLID/GROOVE//JESSE/ROSE//

Design: **Peter & Paul**
Country: **UK**

Plug

Plug is a live-music venue in Sheffield, England. The two posters shown here were designed by Peter Donohoe and Paul Reardon at Peter & Paul to promote the venue and its featured Friday-night artists and DJs. The posters had to reflect the style and attitude of the music—leftfield, edgy, alternative, lo-fi—and be in keeping with the electric theme of the club's identity, which Donohoe and Reardon had previously designed.

Inspired by the name of the club, and the fact that when working on this project an electrician was fitting an alarm in the designers' studio, the solution plays on the theme of electrical components. "We used this as inspiration, but didn't want to be too 'technical,' so the imagery has a humanistic element and a warmth to it," explains Reardon. "Many alternative clubs that play similar music often take it very seriously—the humor within the images is a deliberate reaction to this." The use of the typeface Monospace creates a utilitarian feel, reminiscent of information text on electrical cabling and appliances, while the blocks of color are a reference to the color-guide system used in plug wiring.

Design: **Jason Munn at The Small Stakes**
Country: **USA**

Animal Collective/The Books/Sufjan Stevens/Rogue Wave

The posters shown here were created for performances by a number of different bands in San Francisco. All make great use of typography as a design feature.

Munn's solution for the design of the <u>Animal Collective</u> poster was to make it collage based, "creating layers that obstruct the band name in a way reminiscent of their music, which is very layered," explains Munn. To this end, he has layered plant imagery over the name in green and fluorescent pink. This limited-edition poster was screen printed on an off-white stock.

Found sounds provide the basis of The Books' music; the band layers its own music over the top. Inspired by this, Munn used reels of tape for the "Os" in "Books," acknowledging the many tapes the band sifts through to find suitable sounds. It was screen printed using black and metallic-silver inks on an off-white paper.

"Sufjan was using a lot of clouds in the backdrops of his promotional photos, which inspired this poster," explains Munn of <u>Sufjan Stevens</u>. "The font used for his name is based on an old art deco font, recreated in Illustrator, and is meant to be the sun in the sky." It was a limited-edition screen print using a sky-blue stock and transparent white ink, printed twice, with some of the second print overlapping the first to create depth in the clouds.

Munn's design for <u>Rogue Wave</u> was based on the band's album <u>Descended Like Vultures</u> and their track "California."

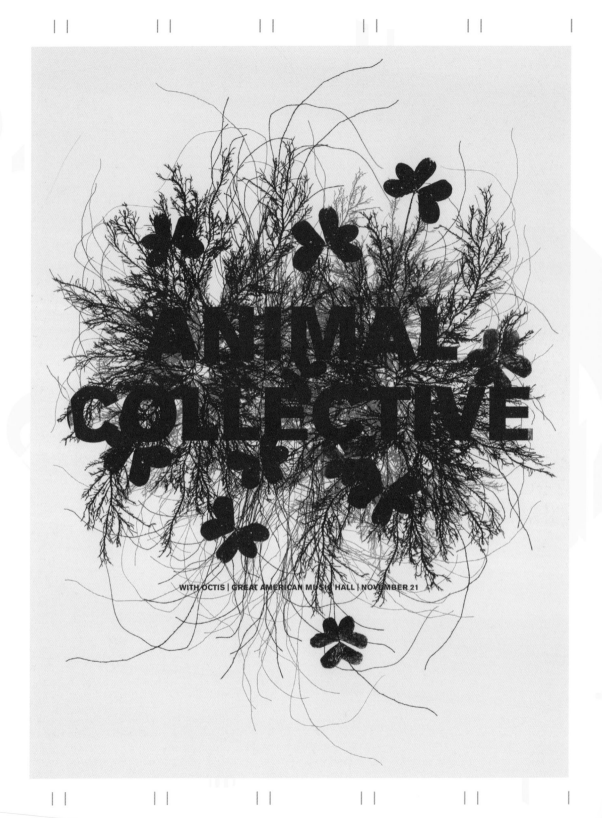

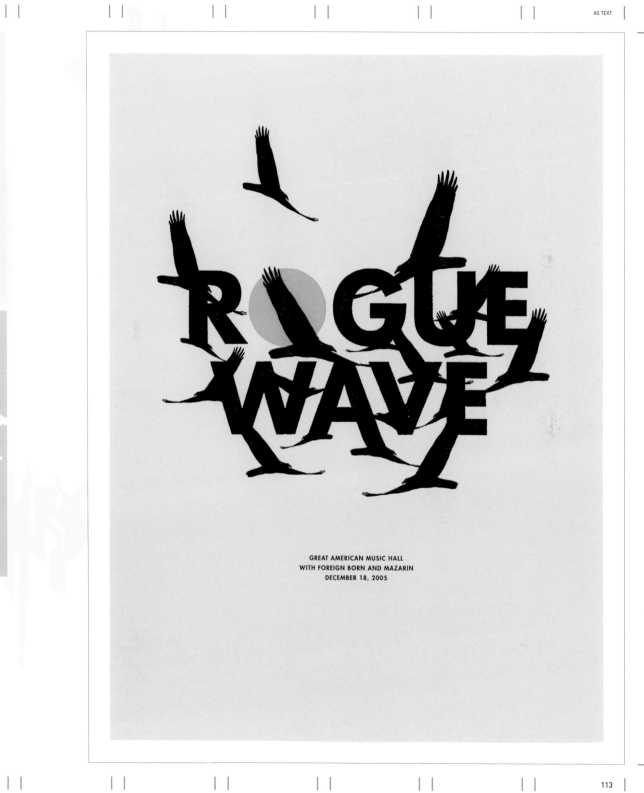

Uwe Loesch, Germany

Which are your three favorite posters of all time, and why?
One of the most intelligent posters is <u>The Heavenly Underground: Keeps London Going</u> (1932) by Man Ray. To create an analogy between the signs of the London Underground and the planet Saturn is pure genius. As a student, I was very impressed by a poster that Hans Hillmann designed for the international sailing competition Kieler Woche 1964. Hillmann managed to make a mark with very easy methods, too. He used four water-blue surfaces, and moved the upper-right surface by a few centimeters so that a white triangle appears that looks just like a sail. Ingenious! The third poster that comes to mind is probably the most well-known poster by Shigeo Fukuda, titled <u>Victory 1945</u> (1975). Placed diagonally on the page on a yellow background you see a black rifle barrel and a bullet that has been turned around. The bullet does not point in the direction of the shot, but back into the rifle barrel. It is so special because it is internationally understandable, is timeless, and is actually nonverbal—it would work without the headline.

Once briefed, how do you approach the design of a poster?
Usually I get a good idea during the briefings, but I mostly don't trust it. The realization will show if a "good idea" is not a "crank idea," so it is advisable to develop alternatives, even if the first layout seems almost perfect. Comparing these results helps you to define judgment criteria. If you try to skip this process, the result remains unsatisfying.

What inspires the creative idea behind each poster you design?
There is no doubt that we are all influenced by our daily surroundings. Our culture determines our creativity and our openness to perceive. The arts, the theater, or the electronic media usually teach us what we find fascinating and inspiring. Kids are very inspiring because they are spontaneous and have the ability to use their perception in a creative way.

What would you say is the most important job of a poster?
A poster should communicate the "better idea." This demand to communicate is a constant challenge. Posters have to be "attractive" in their literal meaning—they have to attract people.

What role do your believe posters play within our culture?
Posters are still extremely important in our culture. Contrary to all predictions, posters have not lost meaning or even disappeared in competition with electronic media. They have kept their place and even become more important on a global scale. Modern culture is too attached to posters. Places like China, that actually don't have a big tradition of posters, have new Poster-Biennals all the time, and they are always surprisingly successful. Students use this boom to make their first marks as designers on an international stage. Thus, a worldwide network of thousands of poster designers has arisen. They have very little commercial interests and transport a lot of political messages. TV and the Internet can be controlled and censored; posters can be placed illegally or shown on international exhibits and called "art." They are like statues. You cannot switch them off or click them away. Their advertising impact is undisputed. One simply cannot avoid looking at a poster, once one has seen it.

Wolfy & Kayrock, Kayrock Screenprinting, Inc., USA

Which are your three favorite posters of all time?
WOLFY: The work for <u>Black Flag</u> by Raymond Pettibon; the graphic work of Aubrey Beardsley, Edvard Munch, William Blake, Gary Panter, and Harvey Kurtzman; the art-show announcements of Martin Kippenberger and Franz West. The posters by Seth Tobacman inspired me to be politically conscious. I look to the design and product logos done by Paul Rand; the posters and ads he created never cease to amaze me.

What is the key to designing a good poster?
WOLFY: When the political pendulum is swinging either extremely right or extremely left, the best poster work is done.
KAYROCK: Intellect and thought.

What inspires the creative idea behind each poster you design?
WOLFY: It is what the client wants and what we are into at the time. A passing thought can be coaxed into great work.
KAYROCK: It is what we are into and what the client wants. The time and number of colors we have usually inform the process.

What do you most enjoy about designing posters?
WOLFY: The need to combine all the information for an event with images. I enjoy the ability to send art and ideas directly into the world as a functional object, but also as a thing of beauty.
KAYROCK: There are times when I want to do everything on the computer and Wolfy wants to make everything by hand. Lately, I have wanted to do things by hand and Wolfy insists on the computer. I think it is the balance of both that keeps it enjoyable.

What would you say is the most important job of a poster?
KAYROCK: A poster should communicate and illustrate an event concisely and beautifully.
WOLFY: A poster should stand out on a wall of other posters and demand attention by saying something the others do not.

What role do you believe posters play within our culture?
WOLFY: The poster is an artifact of an event that should color and create a memory of the experience, and which should be as good or better than the actual event.
KAYROCK: It can function as a document of the cultural landscape and the moment in a more lasting way than the event.

What is the most interesting poster you've seen in recent years?
WOLFY: The posters created by the Mighty Robot Art Collective, and which were mostly designed by Arthur Arbit and Erik Zajaleskowski. The work was simple in execution, yet complex in content and emotion. The abstraction occurred when the arrangement of text met references to art history, inhumanity, war, religion, the impending alien invasion, psychedelia, and spray paint. Much of the work was color-copied and then wheat pasted. Ingenious and easy.
KAYROCK: The Faile Collective. They are graffiti artists based out of Brooklyn and Tokyo. Their work comes from references to comics and pulp images, but they still seem to move beyond the obvious and do something new. They create work that stands out on brick walls as well as gallery walls. They combine stenciling and silkscreening in a way that pushes the limitations of both media and the places where they exist.

04

"What makes this poster so amazing is that he applied the ink to the paper by inking the record and letterpressing it to the paper."

Jason Munn, The Small Stakes, USA

Printing & Finishing

Introduction

The printing techniques that can be used to create posters are many and varied, and, as this chapter shows, the range of materials on which the designs are printed is also broad. Depending on the number of posters that need to be produced—or, indeed, on the budget—designers have the option to really experiment when it comes to the choice of paper stock, inks, and printing finishes.

The following pages exemplify this with work by designers from many different parts of the world, who use materials and techniques ranging from glow-in-the-dark inks, different embossing techniques, and a variety of paper stocks, from the very expensive to leftover newsprint. The finish and materials are as important to the successful communication of the poster's subject matter as the artwork or typography, adding to the overall message that the poster aims to communicate.

Paper Stock

"I experiment a lot with materials and different tactile qualities. I find this can add in a subtle way to the messaging of the poster."

Jonathan Ellery, Browns, UK

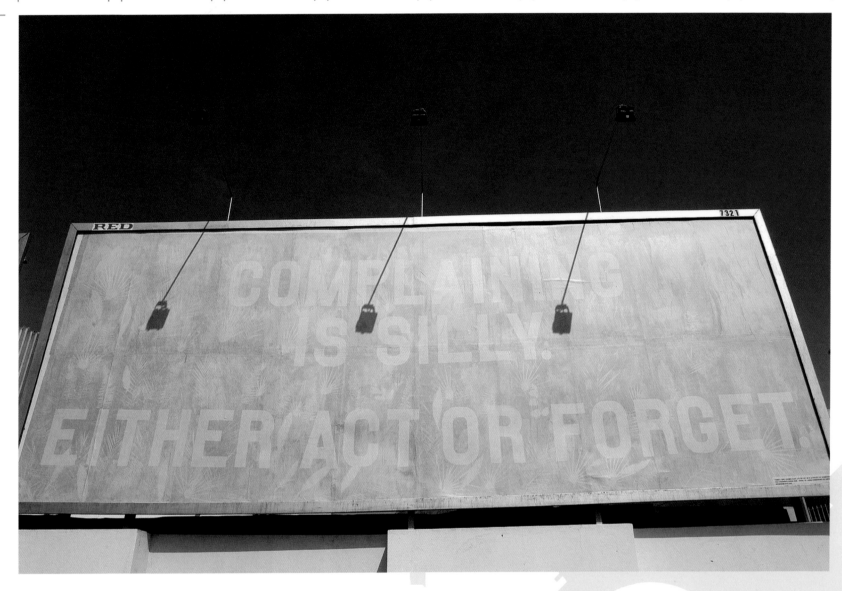

Design: **Sagmeister, Inc.**
Countries: **USA/Portugal**

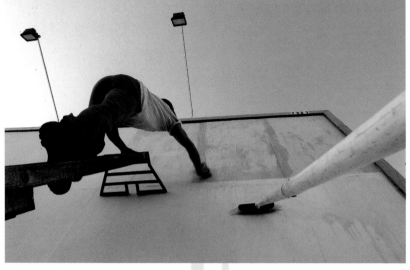
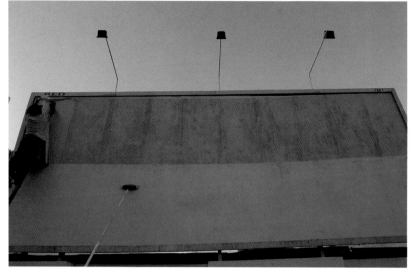
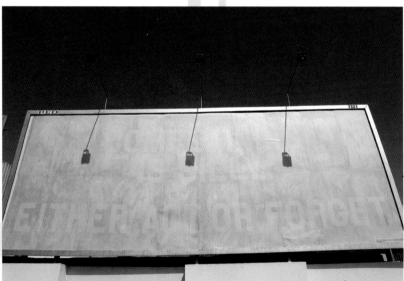
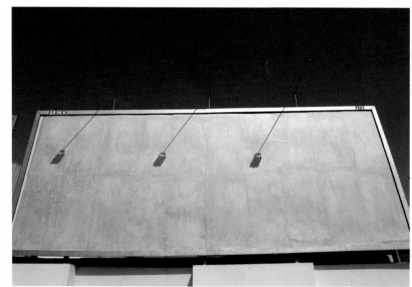

Super Bock

This poster was created by New York–based designer Stefan Sagmeister for Super Bock, one of the most popular beer brands in Portugal. There was no brief given as such, but the designers were told that the poster didn't have to obviously promote the beer brand, but rather, be "engaging."

Because the poster was to be displayed on a billboard in Lisbon, it was decided to create it using newsprint paper stock. Sagmeister and his team wanted to take advantage of the fact that newsprint paper yellows significantly and quickly in sunlight, and created their poster using this yellowing to make the text on the paper.

They started by creating a gigantic stencil of the words for the poster on the roof of their studio in New York. This stencil was then placed over the newsprint paper that had been laid out there. This was then left and exposed to the sun for a full week, and the paper around the letters yellowed to spell out the lines,

"Complaining is silly. Either act or forget." This was then shipped to Lisbon and mounted on the 9ft 6in x 26ft 3in (3m x 8m) billboard where, through further exposure to the sun, the lettering slowly faded away. This is a great example of a lo-fi, seemingly simple design idea.

Design: **Julian Morey Studio**
Country: **UK**

Club 21

These posters were designed to advertise and promote the Club-21 typeface foundry. Both the fluorescent green-and-gold poster and the blue poster were created to promote the release of two new typefaces: Preset-X and Preset-O.

When creating the two-sided posters, Julian Morey was inspired by the work of Wim Crouwel. "The mood I wanted to create was pitched somewhere between Dutch Modernism and Japanese poster design," explains Morey. "The fluorescent green and gold were specifically chosen to give a Japanese feel to the design." Both posters are printed on Fedrigoni Splendorgel Extra White 100gsm paper.

The A–Z poster uses animals to represent letters, with, for example, A for aardvark, K for koala, and V for vole. Each animal has been overprinted with a letter from one of the typefaces designed by the foundry. "It's about taking the idea of typography back to the most basic of forms and injecting some humor into what is often considered a very upscale profession," explains Morey.

The design uses three Pantone spot colors overprinting black, and it was printed on Dutchman Smooth White 120gsm paper.

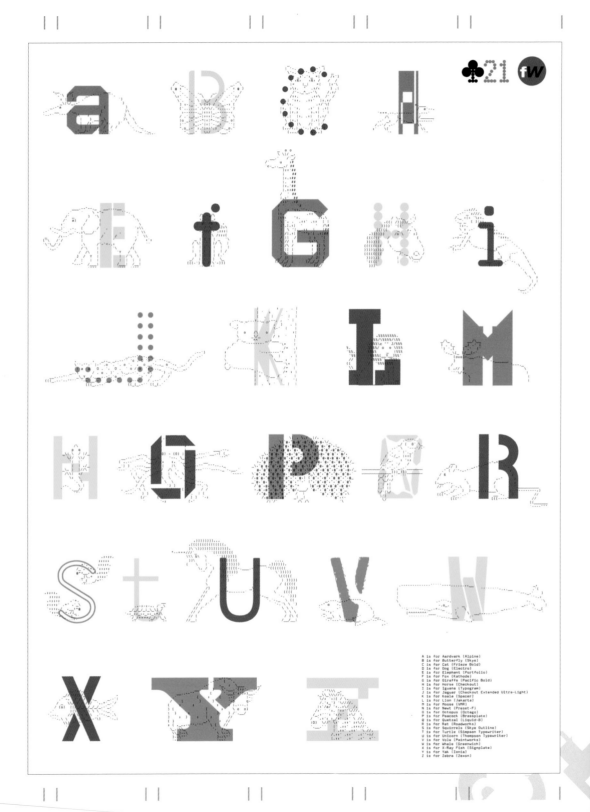

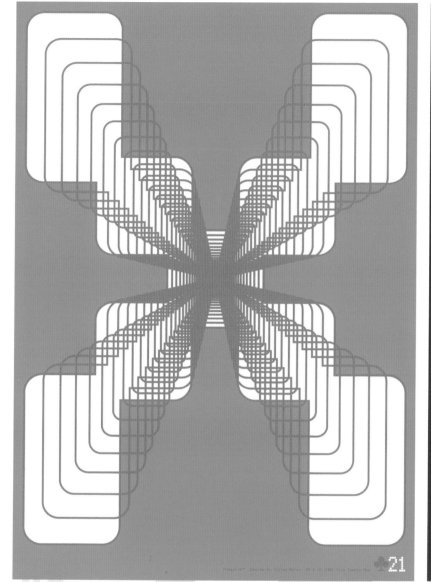

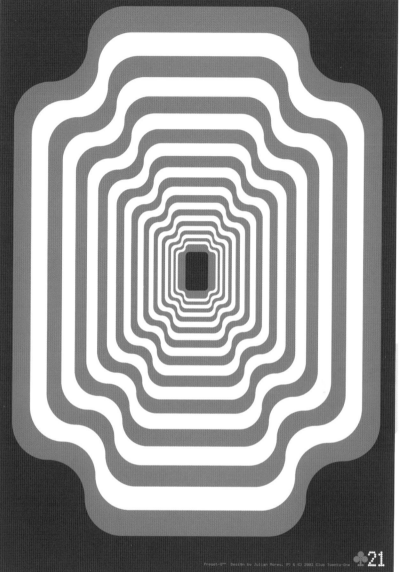

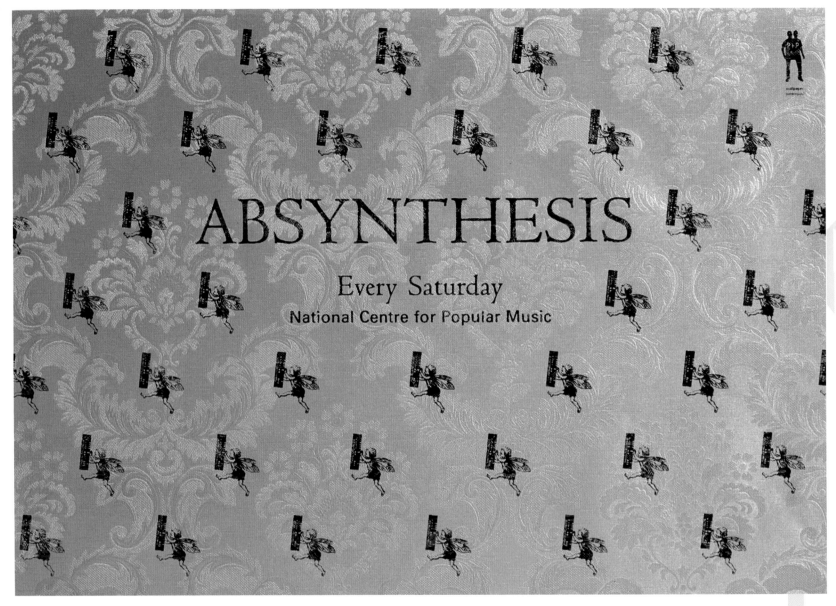

ABSYNTHESIS

Every Saturday

National Centre for Popular Music

Design: Peter & Paul
Country: UK

Absynthesis

This poster was created to promote club night Absynthesis. It had to reflect the theme of the night—electronic music and a stockpile of absinthe—while paying homage to the period in the late 19th century when absinthe was popular with artists for its hallucinogenic properties. "We decided to create something ornate that reflected the style of old French bars,

where artists would happily consume this green liquor into the early hours," explains designer Paul Reardon.

They have used the iconic green fairy, updating the image by picturing her tinkering away on a synthesizer. The design was screen-printed onto wallpaper to give the posters a tactile,

rich feel. Budget limitations meant that there were size restrictions for the poster, but by using wallpaper as a substrate, overprinted with a repeated pattern, the posters could be tiled up together to form a long strip for maximum impact.

Eighty Seven

A new book by Jonathan Ellery
Available July 2006

Distributed internationally by Art Data
+44 (0)20 8747 1061
Printed by St Ives Westerham Press
www.westerhampress.co.uk

Published by Ellery/Browns

Eighty Seven

A new book by Jonathan Ellery
Available July 2006

Distributed internationally by Art Data
+44 (0)20 8747 1061
Printed by St Ives Westerham Press
www.westerhampress.co.uk

Published by Ellery/Browns

Design: **Jonathan Ellery at Browns**
Country: **UK**

87

These two posters were created to promote 87, a book Ellery compiled, wrote, and designed. The book looks at the role of form, materials, pace, and edit in graphic design. The aim of the posters was to communicate all the relevant sales information and to give a preview of the book's design esthetic.

Four typefaces have been used to make the numbers on the posters, two on each: Stripes, Carousel, Countdown, and American Typewriter Light. They were printed on Chromolux paper, a thin stock that has a high-gloss finish on one side and is uncoated on the other. The poster text was printed on the high-gloss side.

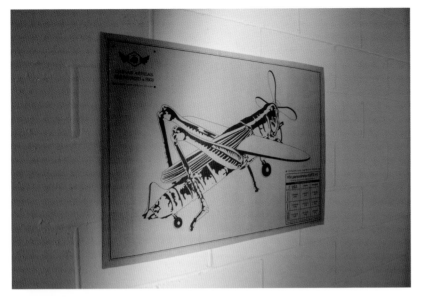

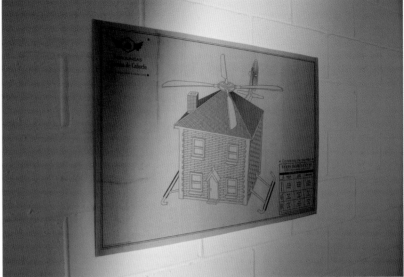

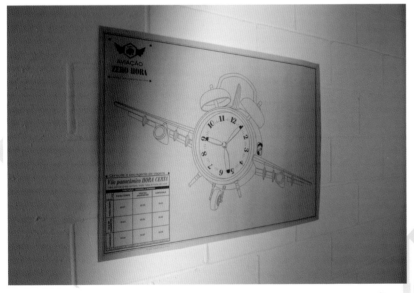

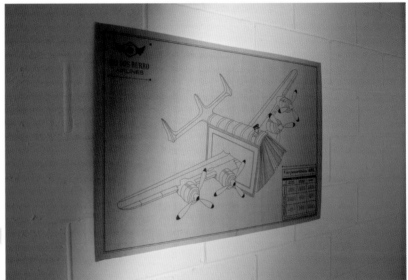

Design: **Julio Dui at Mono**
Country: **Brazil**

Airplanes

Julio Dui created this series of posters titled <u>Airplanes</u> as a personal project. Each poster features an airplane, but each has a different fuselage, ranging from a banana to a book. Inspired by vintage equipment and typefaces, Dui used Macromedia FreeHand to create the images, basing them on 1950s imagery and advertising.

"I wanted something from the past, something lost in time," he explains. "In spite of having designed them on the computer, I wanted them to have a vintage style, which is why I chose older typefaces—Bodoni and some variations of Akzidenz and Din."

The posters were printed on sensitized paper as for an architectural blueprint. What is interesting about this printing technique is that exposure to light changes the color and contrast of the images as time passes, as can be seen here—the top image is before and the bottom image is after.

Design: **Björn Atldax and Karl Grandin**
 at **Vår**
Country: **Sweden**

Steez

Steez is a hip-hop club in Stockholm, and designers Björn Atldax and Karl Grandin at Vår created this poster for a club night there in 2005. The brief was open, but the budget was fairly limited. "I wanted to create an illustration out of all the information on the poster, integrating the text with the other drawings," explains Grandin. "It was going to be displayed on the street, so I wanted to use a really vivid color to attract people's attention, hence the fluorescent pink. I intended to make something that related to graffiti, but wasn't too obvious, sort of Hieronymus Bosch meets Kaws [a designer who made his name as a graffiti artist], with a nice detail level so that you could look at it many times and find something new."

The poster was printed on packing paper—an uncoated, fairly thin stock—and displayed around Stockholm.

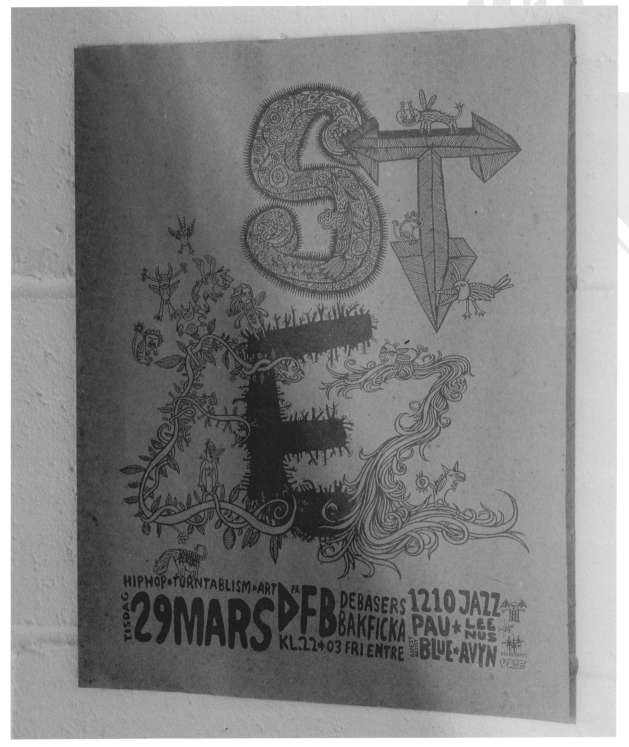

Design: **Ryan Boblett**
Country: **USA**

The Books

This series of posters was created to promote a gig by US band The Books at The Empty Bottle in Chicago. The posters have been printed, rather unusually, on a series of old book covers. This comes not only from the name of the band, but also from Boblett's love of old books. Together with designer and friend Hans Seeger, Boblett collected and gutted 100 books to provide the print stock for the posters.

He then designed the graphic content for the poster, inspiration for which came from the title of the album, Lost and Safe. "It seemed that creating a custom, maze-like typeface [for the band's name] was appropriate," explains Boblett. "I also added polarizing icons—a deer and a flower; a bear and cliffs—and doubled up the design on the books, back and front cover, as it seemed to fit the medium well and was extremely cost-effective."

The posters were screen-printed and displayed around the city of Chicago.

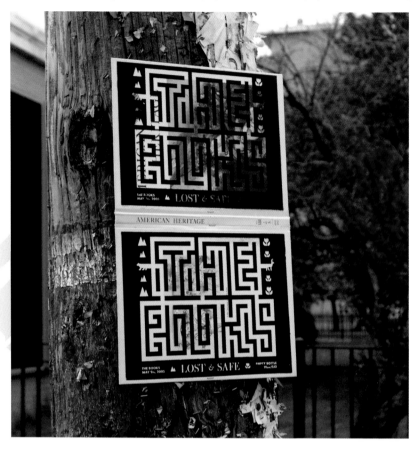

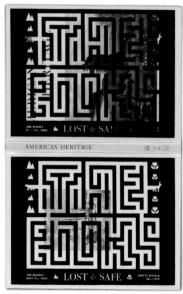

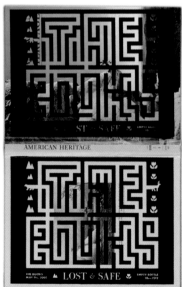

Design: **Ryan Boblett**
Country: **USA**

Remember 9.11.01

This poster was created as a personal project. In the lead-up to the fourth anniversary of 9/11 in 2005, Boblett wanted to "remind and reeducate" people about the event, using a powerful yet simple icon, and print it on posters that could be displayed all over Chicago. "My inspiration came from the power of iconography," he explains. "I took a simple font—Helvetica—and a simple icon—no smoking—and tried to give it

a new meaning. My hope was that every other time you saw the poster you might stop and think of something else."

The posters were printed on newspaper stock at a local newspaper printworks, which enabled Boblett to print thousands of posters at very low cost.

Design: **Studio Apeloig**
Country: **France**

Another America

The 2004 Fête du Livre—the annual
foreign-literature festival held in Aix-en-
Provence, France—focused on writers
whose literature explores the darker side
of the USA. Speakers included Russell
Banks, Richard Price, Francine Prose,
and Patti Smith. The event, held shortly
before the US presidential elections that
year, gave intellectuals the opportunity
to speak publicly about their vision of
the country and describe the flip side
of US society: the poor, the ethnic
minorities, those who have little chance
of succeeding, those not living the
"American Dream."

French designer Philippe Apeloig was
commissioned to design a poster for the
event. "The idea was to divide the poster
into two parts to show the gap that exists
between the two different populations
in America," he explains. "I wanted to
express the rupture, the major divide."

To illustrate this breakdown and division
within the society, Apeloig has set the
text starting in the middle of the page,
then run it off the right-hand edge and
continued it from the left. In this way the
end of the text precedes the beginning.
It is set in red and white to represent the
American flag and to reiterate the idea of
two societies living in the same country.

The poster was printed on cardboard.

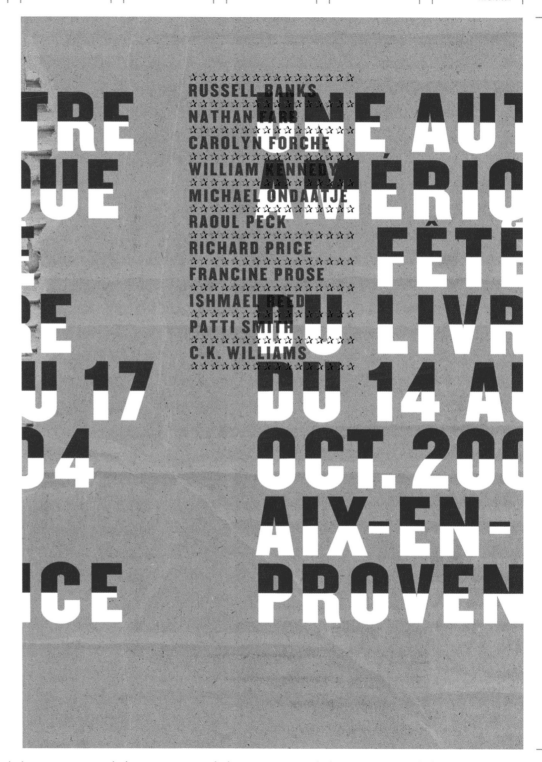

Design: **Brilliant**
Country: **Sweden**

This Year Has Been Good to Me/Ekko

These two posters were designed by Frans Carlqvist at Brilliant. The first was produced for independent Swedish record label Flora & Fauna to promote the debut album by electronic artist Rigas, This Year Has Been Good to Me.

Carlqvist's design combines his own illustrations with computer-generated patterns. "I was inspired by old Swedish folk art and the sound of Rigas," he explains. "With the artwork for the poster I wanted to combine the roughness of my sloppy drawings with exact computer-made patterns, because the electronic music on the album sounds like it's made with wood computers." The poster was printed using two spot colors on an uncoated stock.

The second poster was created to promote Ekko, a festival of electronic music in Bergen, Norway. Carlqvist came up with imagery that he describes as "some kind of fantasy-vector-space-squids," and created a logo typeface consisting of a handmade font combined with Century Gothic. Three Pantone colors have been used to print the poster—black, fluorescent blue, and fluorescent pink. While the intention had been to print on an uncoated stock, this was later changed to coated stock at the client's request.

Design: **Björn Atldax and Karl Grandin**
 at **Vår**
Country: **Sweden**

The Autumn

JC is one of Scandinavia's biggest clothing chains. This poster was designed to promote JC's new jeans collection. Atldax and Grandin had previously created a number of large-scale hand-painted screens (63 x 94½in/160 x 240cm) for use in a photoshoot for the brand, and they decided to use some of the imagery from these on the poster.

"The tree and the character in it are from one of those screens," explains Grandin. "Since the poster was going to be sent out folded in translucent envelopes, I decided to print it on the same paper as the envelope, so it would look strange when people got it in their mailboxes."

The transparent stock that was used is called Manifold, a stock that can be folded over and over again without tearing.

Design: **Kayrock Screenprinting**
Country: **USA**

Viza Noir
The poster above promoted a gig by the band Viza Noir. Wolfy and Kayrock decided to print the poster on some old vinyl albums they had been given. A simple typeface was chosen for legibility, and vinyl ink was used to print on the vinyl record. It was displayed around Williamsburg and Brooklyn, New York.

Papa Crazee Benefit
Continuing the record theme, Kayrock used record covers on which to print a series of posters to promote a benefit show by the band Papa Crazee. "We already had the record sleeves," explains Wolfy, "so we decided to use them, and created a pattern to cover 90 percent of the sleeve surface, then printed the main poster drawing over that."

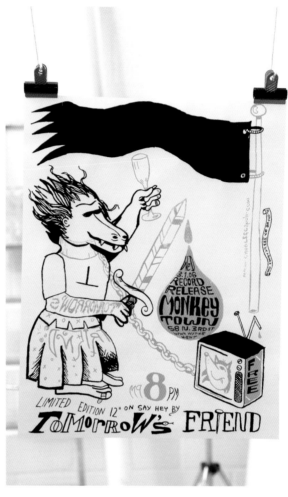

Tomorrow's Friend

This <u>Tomorrow's Friend</u> poster was devised to advertise a record release and gigs by the band. The designers have used a vellum stock, which is heavy enough to allow printing on both sides, so the poster was used to announce two separate shows. The fox chained to the "performing" baboon on the television is a dig at the masses who seek their "reality" in Fox News.

Till by Turning

Till by Turning are a classical-music group. Kayrock scanned in musical symbols and references, and arranged these in Photoshop to create the face. The font is based on Wolfy's handwriting.

Inks & Finishing Techniques

"The solution came from the book's production. We took the overprint sheets directly off the press on which the book was printed."

Christian Küsters, CHK Design, UK

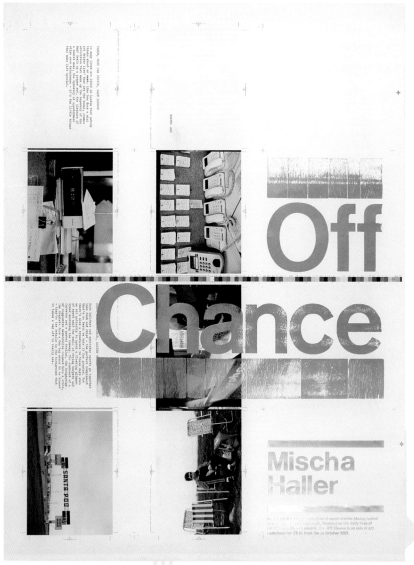

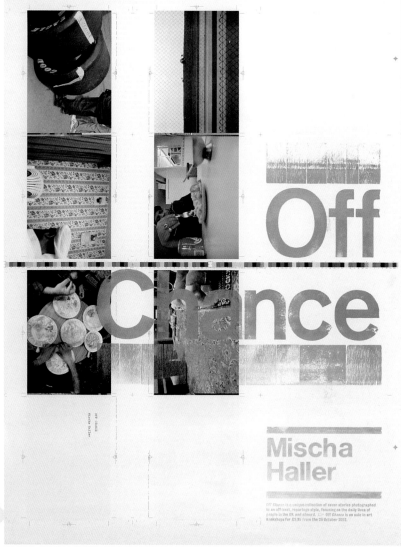

Design: **CHK Design**
Photography: **Mischa Haller**
Country: **UK**

Off Chance

These posters were designed for the launch of photographer Mischa Haller's book, <u>Off Chance</u>. Art director Christian Küsters and designer Darren Hughes of studio CHK were commissioned to create a poster to announce the book launch, costing as little as possible to produce.

"The solution came from the book's production," explains Küsters. "We took the overprint sheets directly off the press on which the book was printed, and thus only had to print one color to announce the book launch. The idea was to use the title as method. The final outcome is more or less random and shows elements of the book."

Design: **Studio Oscar**
Photography: **Oscar Wilson**
Country: **UK**

Acid Armadillo

This series of posters was created by Oscar Wilson for It magazine. In 2000 It produced an alphabet issue, and asked a number of artists and designers to create an image of some sort to represent a particular letter. Wilson decided on A, and "A is for Acid Armadillo."

"Inspired by 1960s' American psychedelic-rock-poster designers, we created Acid Armadillo, a mock film poster for a fictitious 'rockumentary' about the [real] post-punk, funk-rock band Gramm—formerly Gramme," he explains. "The model featured on the poster is Sam Lynham, who is the lead singer of Gramm. We transported her back to the mid-to-late 1960s for the shoot."

The Acid Armadillo logo typeface on the poster was hand-drawn, then scalpel-cut from ruby-lith film. The original artwork has been screen-printed using oil-based inks on a coated, slightly shiny stock. Some of the inks used were quite thin, allowing extra colors to emerge through overprinting. Subtle color blends and inks mixed with gloss varnish have also been used throughout.

The posters were featured as part of a box set from It magazine and they have been displayed at a number of exhibits. The shoot was photographed by Oscar Wilson, hair was by Chris Munt, makeup by Julie Jacobs, and styling by Yeda Yun.

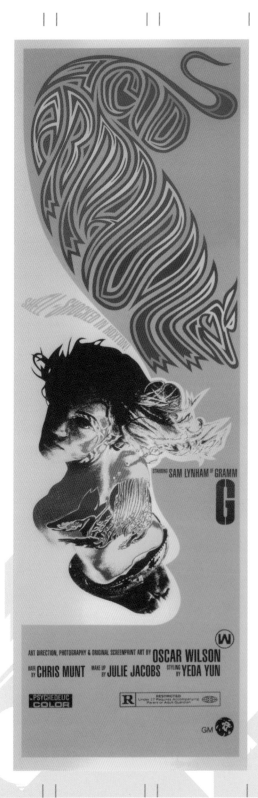

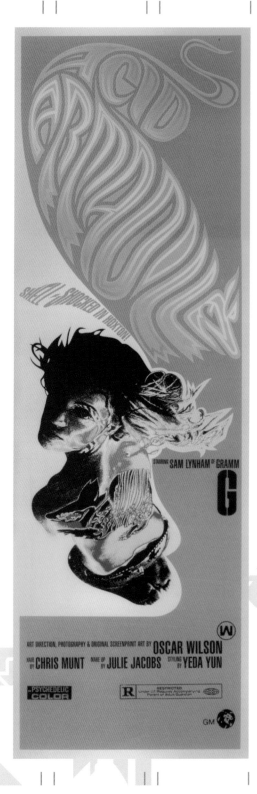

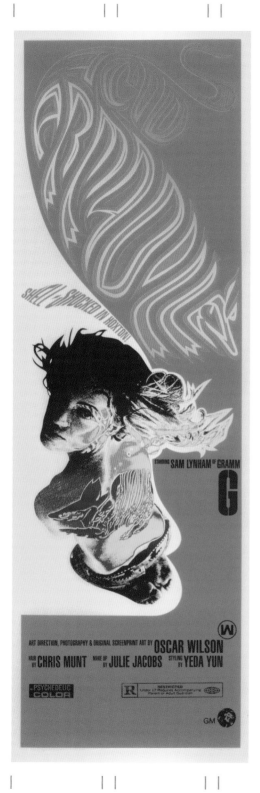
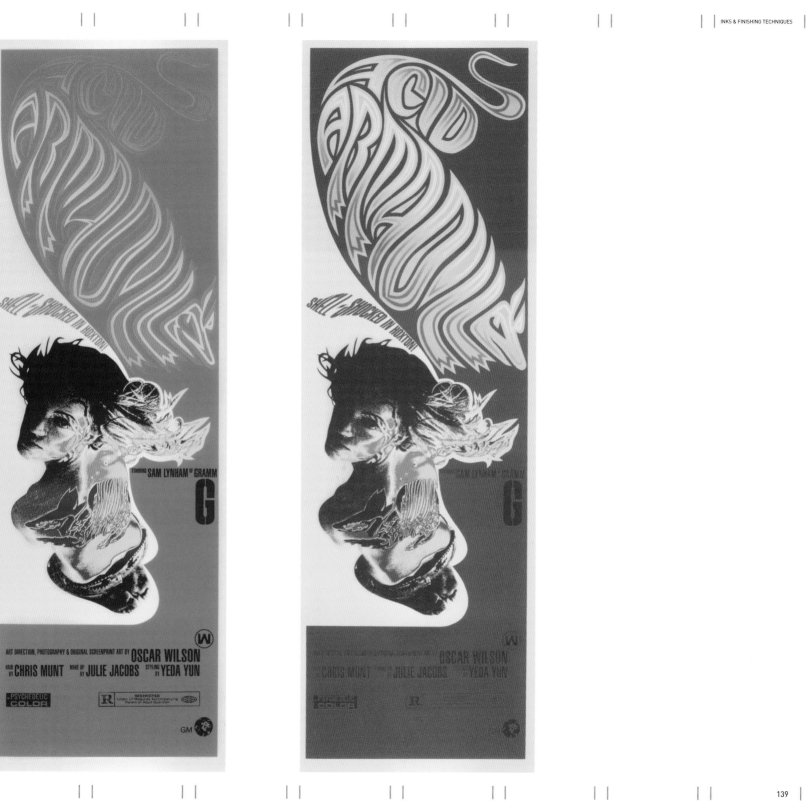

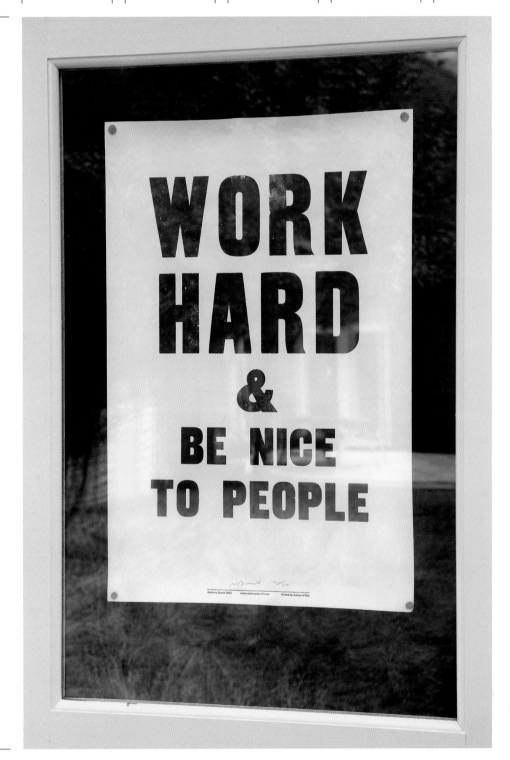

Design: **Anthony Burrill**
Country: **UK**

Woodblock

These posters were originally designed as promotional items to be sent out to potential collaborators. They were printed using woodblock type.

Inspiration for the posters came from a lady Burrill encountered at the supermarket. "I was standing at the checkout one day, listening to an old lady talking," he explains. "After a rambling conversation about chocolate cookies and cat food, the old lady told us all that the secret to a happy life is to work hard and be nice to people."

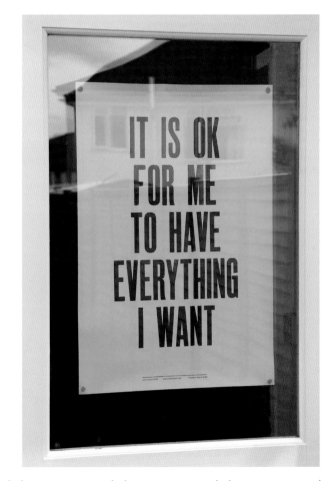

Design: **karlssonwilker inc.**
Country: **USA**

Dáni Kúlture Íslanðá

This poster was produced for Balkankult, a cultural organization based in Serbia, to promote the "Icelandic Cultural Days" event held in Belgrade. The design is uncluttered, with simple black text—including the festival's logo, also designed by karlssonwilker—set against a plain white background. However, what is truly unique about this poster is the addition of the die-cuts. This allowed small sections of the poster, featuring Icelandic sayings translated into Serbian, the language of the host country, to be pushed out and removed. The sayings included: "It is better to be unmarried than badly married," "The worst guest is the one who stays for three nights," and "Happiness follows the idiot."

As Jan Wilker explains, "The die cuts were meant to make the poster 'melt' into whatever background or environment it's put in, since the festival was about two cultures meeting." The die-cut sections were collected and given out to the guests at the opening ceremony of the festival. The print run of the poster was set to 4,700, which made the number of die-cuts the same as the population of Iceland.

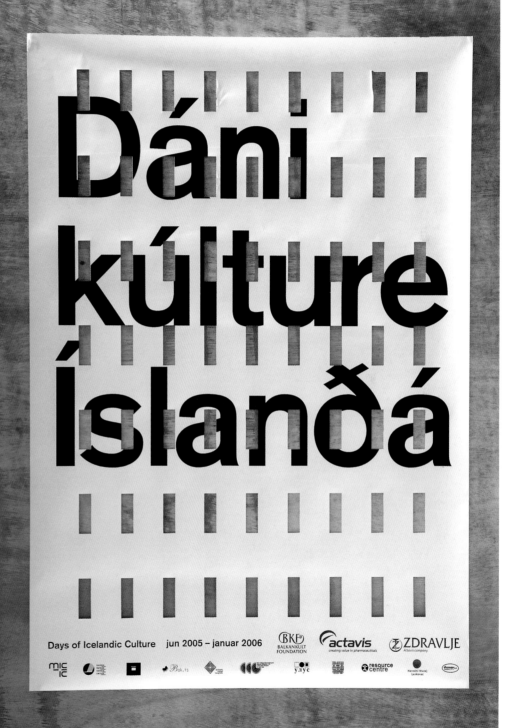

Design: **Art Chantry**
Country: **USA**

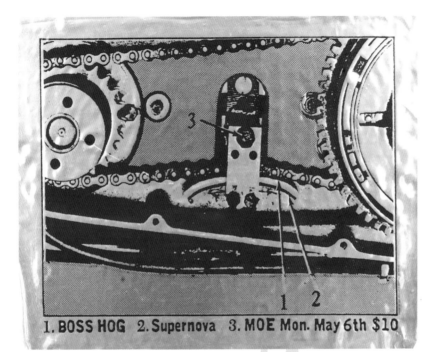

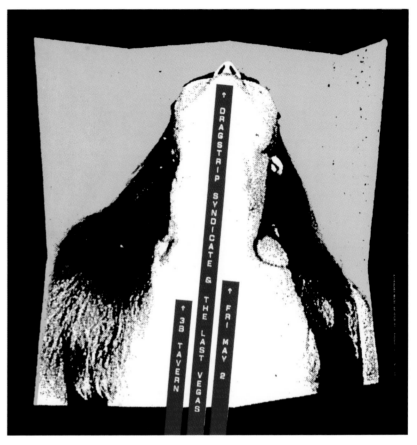

Boss Hog

This poster promoted a gig by Boss Hog. "Boss Hog" is biker slang for a motorcycle, so the use of a motorcycle chain gear seemed appropriate imagery to use. However, the substrate that the poster has been printed on is pretty unusual. It is silver plastic mylar.

"We got a roll of the material, and then cut it out to poster-size pieces, and silkscreen-printed the poster imagery onto it," explains Chantry. "That's the great thing about silkscreen printing—you can print on almost anything." The poster was printed by Brian Taylor.

Dragstrip Syndicate

This poster was created for a concert by punk/garage artists Dragstrip Syndicate. "I wanted to create the effect of being punched in the chin by the event," explains Chantry.

To achieve this, he laid the text—created with a label-making lettering device bought in a thrift store—over a thrown-back head. The idea is that the strips of tape—the event—are literally coming up from below and smacking the viewer in the chin. The poster was silkscreen-printed by Scott Frederick.

Student Art Contest

Chantry created this poster while studying for his degree. "I was hired to design an advertising poster to promote the annual springtime student art contest at the university art gallery," he explains. "In those days, everybody wore home-made, cut-off blue jeans, so I used my favorite pair to make this poster."

He stiffened the fabric with marine spar varnish and made letterforms out of chipboard, which he glued to the jeans. This ensemble was then used to emboss the paper, so creating the effect Chantry wanted. The event details were printed on each poster before it was run through an etching press.

Belltown

In Belltown, an area of downtown Seattle undergoing gentrification, a group of stalwart citizens managed to hold onto a small portion of real estate that they used as a "p-patch," a Seattle term for a vegetable patch. Chantry came up with this poster to announce the reopening of the Belltown p-patch to the few remaining locals and their supporters.

"I was asked by the Belltown P-patch Organization to produce this poster to reflect the mood and do-it-yourself wholesomeness of the event," explains Chantry. "I drew upon the grand old-time tradition of American poster-flyers and civic announcements." Wood type was used to create the text, and the artwork was silkscreen-printed by Brian Taylor.

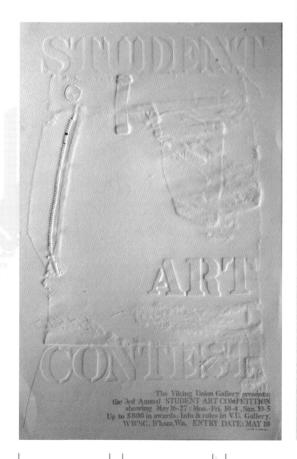

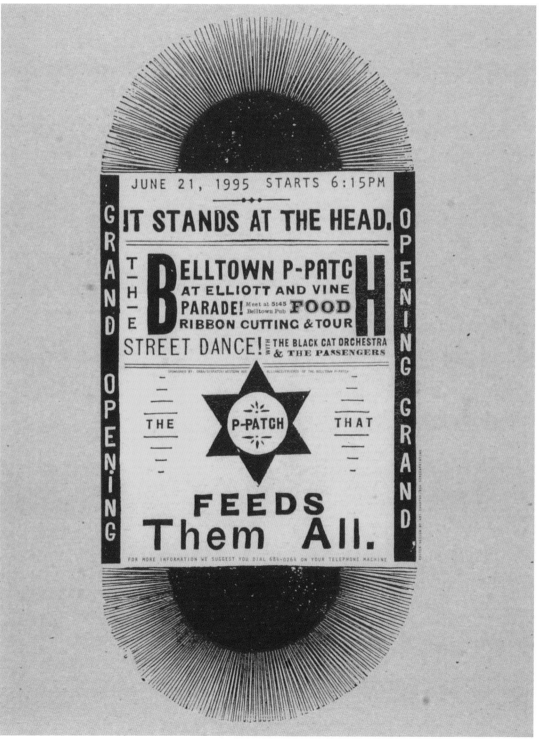

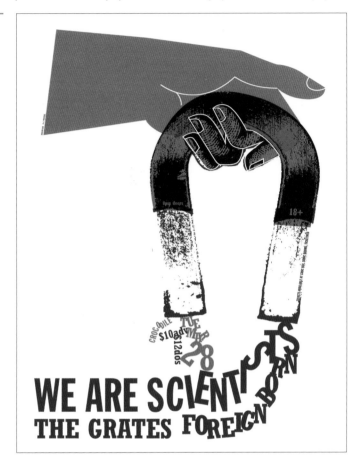

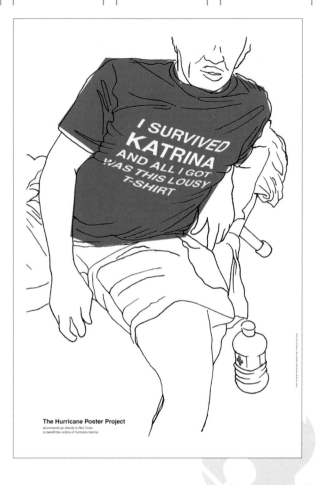

The Hurricane Poster Project
all proceeds go directly to Red Cross
to benefit the victims of Hurricane Katrina

Design: **Modern Dog Design**
Country: **USA**

We Are Scientists, The Grates, Foreign Born/ Katrina

This first poster was created for the Crocodile Café in Seattle to promote performances by the bands We Are Scientists, The Grates, and Foreign Born. The brief was to keep it simple. "I saw the word 'scientist,' and immediately thought of a magnet," explains designer Vittorio Costarella. "I was a pretty simple kid, so picking up nails with a magnet was high science to me, and having the type attracted to the magnet worked out perfectly—just all stuck together as if made out of metal."

The magnet-and-hand image is constructed from a photograph of a magnet taken from an old magazine and combined with photocopied fingers, the

whole thing cut out and blown up on a xerox machine. Some illustration was added to define the hand. The poster was then silkscreened red and blue, with the third, darker color being a mix of the two.

The second poster was designed for the Hurricane Poster Project, which aimed to raise money for the Red Cross in the wake of Hurricane Katrina in 2005. "Our brief was only to design a poster to help raise money for Red Cross in regards to Hurricane Katrina," explains designer Robynne Raye. "The subject matter and imagery were left totally open. I wanted to create a poster that showed some of the frustration everyone experienced at the lack of an official national response."

Michael Strassburger, also of Modern Dog, adds, "I like posters that have more than one level of engagement. When you first see this poster it comes across as light humor. Then, with only a little reflection, the humor makes a statement of frustration and neglect." The poster has been silkscreened in two neutral colors. "I wanted the poster to be a raw personal statement."

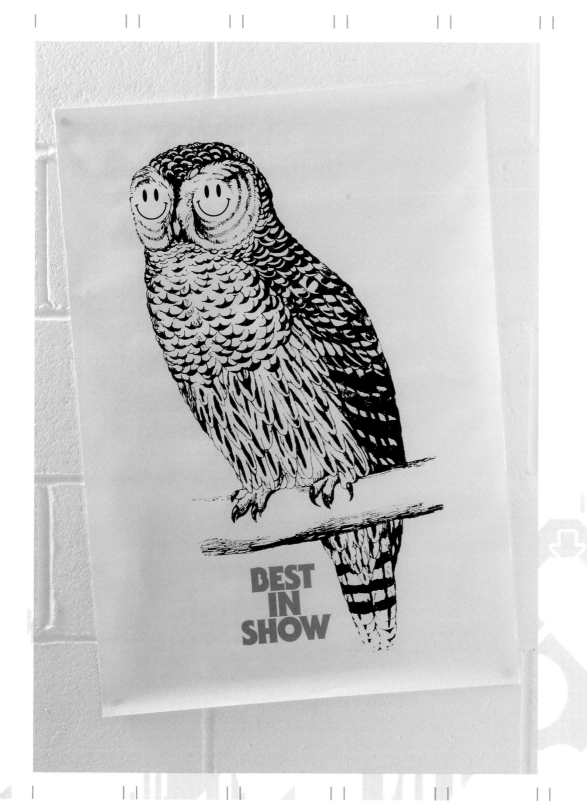

Design: **Karl Grandin at Vår**
Country: **Sweden**

Best in Show

This poster is part of a wider, self-initiated project by Swedish designer Karl Grandin. The owl image featured—titled <u>Nightlife</u>—is, as he explains, "basically about nocturnal urban life and my own experiences of growing up." The image has been used in various ways in a number of pieces, including this poster—which has been used as a giveaway to friends and colleagues, as well as being posted on the streets of Amsterdam and Stockholm. It has also been used on limited-edition T-shirts, and as a light projection on the Stedelijk Museum during the annual Museum Night event in Amsterdam.

The poster is silkscreen-printed in two colors, using a single printing frame.

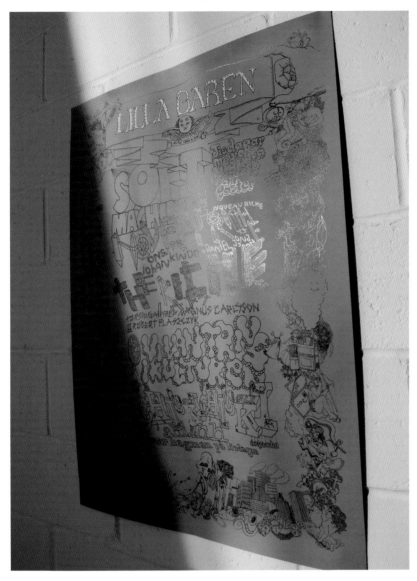

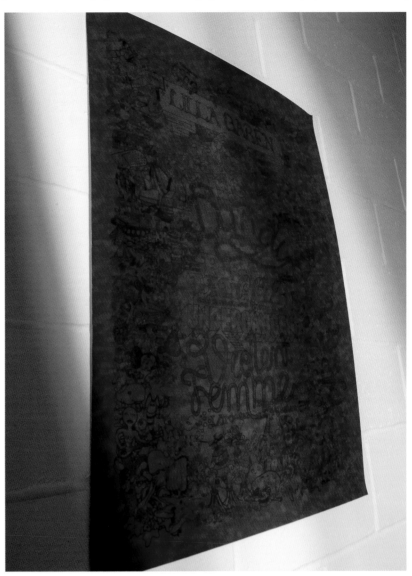

Design: **Björn Atldax and Karl Grandin**
at **Vår**
Country: **Sweden**

Lilla Baren

These two posters were designed for Lilla Baren, the "small bar" at Stockholm restaurant Riche. Each summer Lilla Baren hosts a number of clubs with a wide variety of music; these posters promote the events and list daily schedules. The design brief was to inform the public about the club nights and communicate the "vibe" of the events. "We decided to make a poster that gives you a feeling of the wondrous chaos and magic that goes on in the bar at night. The ceiling at Lilla Baren has some amazing stucco ornaments by the famous sculptor Carl Milles which inspired us to create this bizarre yet strangely classic-looking form. All the typography, characters, and shapes are hand-drawn, reflecting the exciting mix of people and highbrow and lowbrow culture at Lilla Baren," explains Grandin.

The posters were printed in limited runs of 100, and all mix unusual materials and printing techniques. The green poster is a one-color wax print and single-color silkscreen on Krafkartung stock; the red is two-color silkscreen on SEF stock.

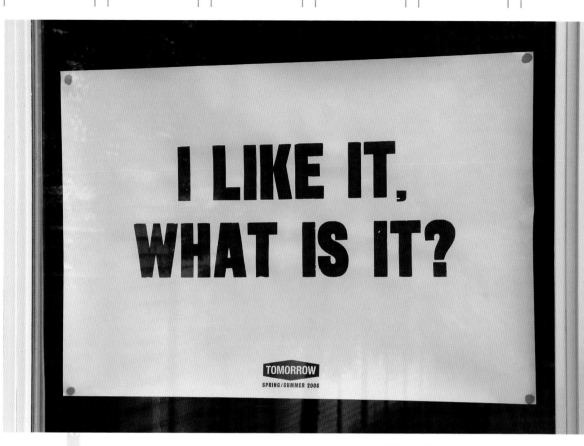

Design: **Anthony Burrill**
Country: **UK**

Tomorrow

This collection of posters is the result of a collaboration between Burrill and fashion designer, art director, and photographer Jethro Marshall. The pair wanted to create a series of products under the brand name "Tomorrow," including posters, stationery, bags, badges, and pencils.

"The designs came out of a conversation between myself and Jethro," explains Burrill. "We worked with a number of texts before deciding on Tomorrow as the name for the brand, and 'I like it, what is it?' as the first phrase. The phrases will change as we produce new products."

Burrill supplied a rough idea of a layout, and the printers then set everything using woodblock type, so the layout and typeface were determined by the woodblock available at the printers.

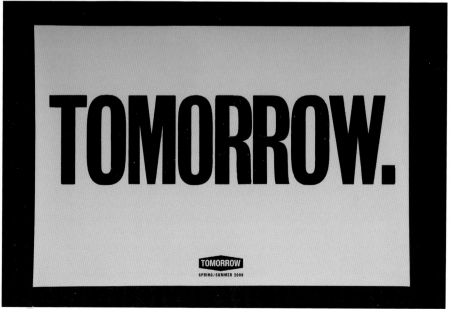

Design: **Unfolded**
Country: **Switzerland**

Spiilplätz

Spiilplätz—which translates as "playgrounds"—is an annual youth-theater festival designed to give the younger generation in the Swiss theater an opportunity to meet for an intensive week of discussions, workshops, and plays. Unfolded was commissioned to create and design the identity and subsequent material for the event, including this poster to promote it.

Inspired by DIY culture, the poster can be "made" by anyone. "As usual for cultural projects, there was a very tight and small budget, so we decided to develop a DIY kit for the poster," explains designer Friedrich-Wilhelm Graf. "We supplied blank DIN A2 [16½ x 23⅜in/420 x 594mm] posters, stamps containing the logo and address details for all the different venues, and adhesive tape containing the complete festival program. Each participant was then able to create and put up posters themselves."

Design: **Julio Dui at Mono**
Country: **Brazil**

Guru

This poster was created by Brazilian designer Julio Dui's commercial company Grafikonstruct, to wish his clients a Happy New Year for 2006. Earlier in the year Dui had been moved by the Eden Ahbez-penned song "Nature Boy," performed by Nat "King" Cole, and he created three illustrations based on the feelings that the song inspired in him.

"As the song describes somebody that was influenced by the power of nature, somebody inspired by the power of Mother Nature, and somebody that fits his life to live close to nature, I tried to catch the same idea," Dui explains.

When it was decided to create the New Year poster, Dui wanted to use one of these illustrations. It was silkscreen-printed using two Pantone colors, one of which was glow-in-the-dark. "I wanted to use the fluorescent color, as it doesn't glow in the daylight, only at night, which I thought was perfect to show how a person can be in perfect harmony with nature," explains Dui. "Like a guru, like somebody who has discovered God and found illumination, the fluorescent color was so perfect to represent it."

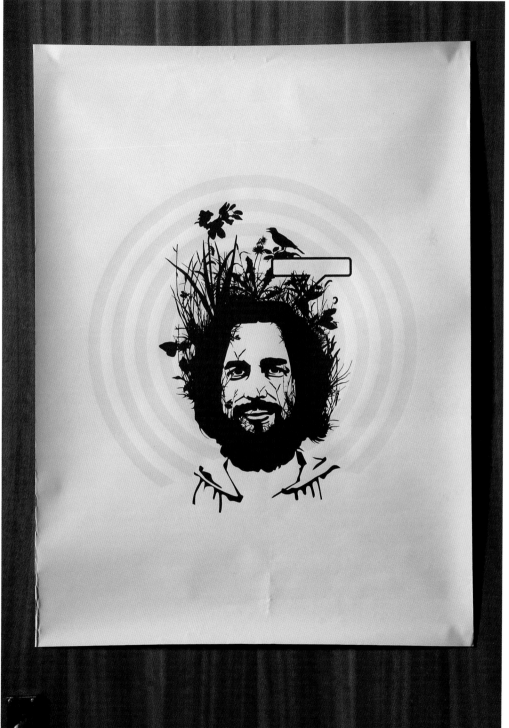

Design: **Alexandre Bettler**
Country: **UK**

Self-promotional/
Again!/Abake

The first poster here is a self-
promotional, letterpress piece made in
collaboration with artist Sam Messenger.
It is part of a series of work that Bettler
undertook about the subject of "nothing."

The black elements on the poster are
the wooden reglets (spacers) used in
letterpress printing to fill the spaces
between the metal letters. They do not
usually print, and so are shown here to
reveal the void, the "nothing" space, that
they usually make. The yellow alphabet
is also made of wooden letters.

The second poster was designed for an
exhibit Bettler curated titled "AGAIN!"
The poster was laser-printed on the
inside of recycled envelopes, and displays
the different patterns that are found on
them. It was then die-cut with the shapes
of trees, and these leftover tree shapes
were displayed next to the poster to give
the impression of a forest. The trees all
had different printed patterns.

The third poster was produced for a
collaborative event with design studio
Abake. It was printed using Abake's
home-made screen-printing press, which
uses glue instead of film, and was printed
on food-wrapping paper found by Bettler
in local kebab shops.

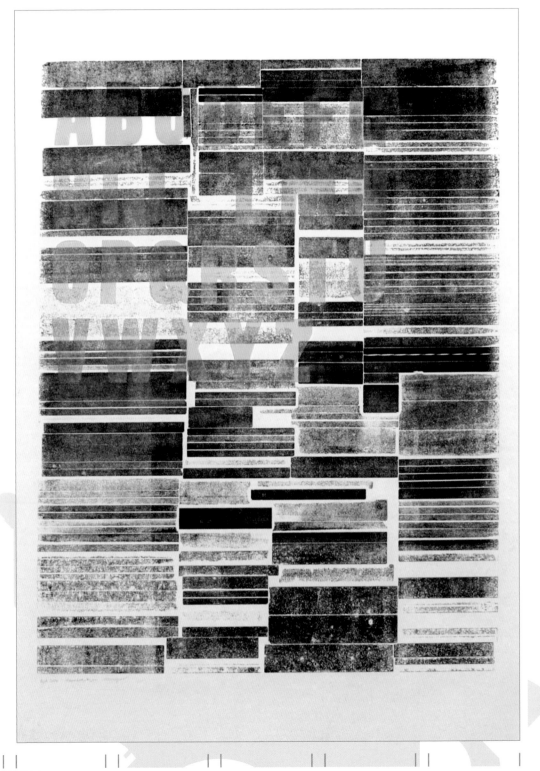

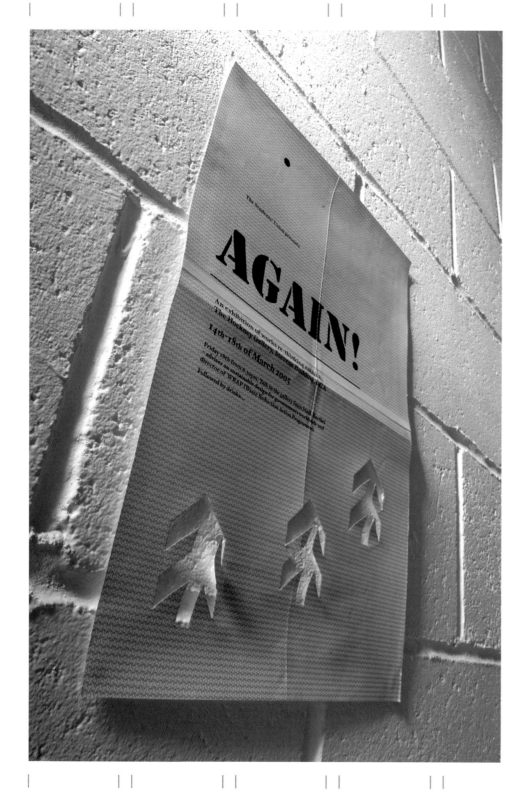

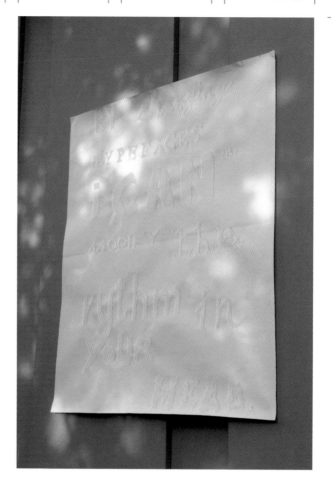

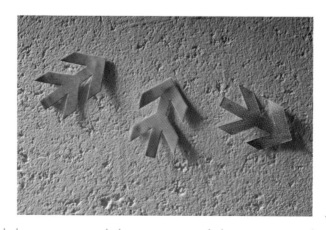

Jonathan Ellery, Browns, UK

What is the key to designing a good poster?
I'm supposed to say things like "easy to read," "direct," or "immediate," backed up by "visual simplicity." The truth is, I don't know any more. Posters are becoming so much more sophisticated that maybe you don't have to read it—or there isn't anything to read in the first place—but still the message gets across.

Once briefed, how do you approach the design of a poster?
My first ideas tend to be the best, or so my experience would suggest, so it's quite a quick process thereafter, trusting my intuition with format, colors, materials, type, or whatever finds its way onto the poster. I experiment a lot with materials and different tactile qualities. I find this can add in a subtle way to the messaging of the poster.

What inspires the creative idea behind each poster you design?
Generally it's the subject matter of the particular poster I'm working on. I don't really have a set style or approach to designing posters other than to enjoy doing them.

What do you most enjoy about designing posters?
I enjoy its restraints. In a way, it's the ultimate design challenge, one clean canvas of any size for you to screw up ... or not.

What would you say is the most important job of a poster?
I take the pressure off myself these days, and don't make the poster have to do too much. From my perspective, it has to represent myself and the way I think. I see it more as art, in a way. A lot of my recent posters are solely for me, with no client as such.

What role do you believe posters play within our culture?
I think posters have a huge cultural significance in modern life, for good and bad reasons. On one side, you have the gross, crass, and disturbingly dark bombardment on our everyday lives from people trying to sell us things, and on the other, you have the gentle delivery, with no sell attached, from artists and designers who feel the need to contribute and say something on a cultural level.

What is the most interesting poster you've seen in recent years?
The work and commitment to posters that the London-based designer Henrik Kubel is producing are fantastic. There is a welcome return to classicism that can be seen in his work. His posters are always very simple, not relying on the tricks of production. He chooses to focus on form, type, and the beauty of the written word.

What do you think is the future of poster design?
The future of the poster is not in doubt; its restrictions have always been clearly defined. It ebbs and flows in profile and popularity. It is currently enjoying a resurgence of interest—for instance, with the publishing of this book. There will always be someone wanting to sell you something or be pissed off enough about something to be driven to design a poster.

Philippe Apeloig, Studio Apeloig, France

Which are your three favorite posters of all time?
L'Etoile du Nord (1927) by Cassandre, Vormgevers (1968) by Wim Crouwel, and Paul Newman (2001) by Ralph Schraivogel. They are good because of the concept behind the design—a witty and risky manner of dealing with the subject makes the design unique—and also because of the quality of the mix of type and images (just two), the composition, the obvious modernity, the emotion that is carried by these posters, the optical illusion, the easy memorable form that comes out of them. The proportional harmony makes them timeless.

What is the key to designing a good poster?
To find a concept that is visually powerful enough to ensure that people will remember the image the designer creates. It is to be able to communicate something quickly, strongly, with something new. A good poster is an aggressive image that must bite the eyes of the viewer and open his thinking.

Once briefed, how do you approach the design of a poster?
First, I need to find the right documentation about the subject. I definitely need to be involved with the topic. That is maybe one of the most exciting parts of the design process—the designer must spend a lot of time learning before being able to communicate something. Then I always start with typography. I look for all the possibilities that the type, coming from the title of the poster, will bring. The layout is born from the random, and slowly it evolves toward something that looks exact, as if it was already there. It arises from hand-drawn sketches or on the computer. I usually make a lot of use of the grid system to make my designs stable, or unstable; in such cases I will go over the guides of the grid, as if I were looking to escape from it.

What inspires the creative idea behind each poster you design?
The inspiration is a nonstop exercise. It comes because designers learn to watch and also not to see. Usually people are lazy with their eyes. A graphic designer cannot be lazy. He must exercise his eyes all the time. It is about absorbing what society and the history of art and design bring to us, and later how to refine our vision by learning to focus on an inside world. Personally, I am also very much inspired by paintings and sculptures. It could be ancient masters. I found similarities between modern sculpture—I think about Henry Moore, Brancusi, or Calder—and typography. It is all about the feeling of space, shapes, and movement. I think of letters as motion.

What do you most enjoy about designing posters?
When I design a poster, I enjoy focusing my ideas on one single image. It is like writing a condensed text, avoiding the unnecessary. It is difficult to design something simple that works well. I like this intellectual manner of approaching the design. I also like to think that the design I do will be on show in the street, in an environment that I cannot control. For that reason I am obsessively meticulous. It is like a gift to the urban landscape. This is the theatrical dimension of design—perhaps it is because posters are usually quite large that I feel happy being a poster designer.

Contact Details & Acknowledgments

Contact Details

178 aardige ontwerpers
info@178aardigeontwerpers.nl
www.178aardigeontwerpers.nl

Alexandre Bettler
hello@aalex.info
www.aalex.info

**Andreas Emenius Company
(Andreas Emenius)**
studio@andreasemenius.com
www.andreasemenius.com

Angela Pelzl
angela@circletdesign.com
www.circletdesign.com

Anthony Burrill
anthony@friendchip.com
www.anthonyburrill.com

Apeloig Design
apeloig.philippe@wanadoo.fr
www.apeloig.com

art chantry design
art@artchantry.com
www.artchantry.com

Bankerwessel, Jonas Banker
info@bankerwesssel.com
http://bankerwessel.com

Blam at Neue
blam@neue.uk.com
www.neue.uk.com

Blanka
info@blanka.co.uk
www.blanka.co.uk

Brilliant (Frans Carlqvist)
frans@brilliant.nu
www.brilliant.nu/frans.html

Browns
info@brownsdesign.com
www.brownsdesign.com

Chris Rubino
crubino@studio18hundred.com
www.chrisrubino.com

Christian Küsters
mail@chkdesign.com
www.chkdesign.com
www.acmefonts.net

Clarissa Tossin
ola@a-linha.org
www.a-linha.org

Clea Simonsen
hello@heutemorgen.com
www.heutemorgen.com

Corey Holms
corey@coreyholms.com
www.coreyholms.com

Cyklon
cyklon@cyklon.dk
http://cyklongrafik.net

Daphne Heemskerk
info@daphneheemskerk.com
www.daphneheemskerk.com

Dipesh Pandya
work@dipeshpandya.com
www.dipeshpandya.com

FL@33
contact@flat33.com
www.flat33.com
www.stereohype.com

Form
studio@form.uk.com
www.form.uk.com

Frost Design, Sydney
info@frostdesign.com.au
www.frostdesign.com.au

Fuszion Collaborative (John Foster)
john@fuszion.com
www.fuszion.com

Grafikonstruct
dui@mono.com.br
www.grafikonstruct.com.br/
www.mono.com.br

Grandpeople
post@grandpeople.org
www.grandpeople.org

Gunnar Vilhjalmsson
gunnar@deluxe.is
www.deluxe.is

Gustavo Lacerd
gustavo@substantivo.net
www.substantivo.net

Hansje van Halem
hansje@hansje.net
www.hansje.net

Helena Fruehauf (Castaic)
helena@castaicdesign.com
www.castaicdesign.com

Hjärta Smärta
hjartasmarta@woo.se
www.woo.se

Hyperkit
info@hyperkit.co.uk
www.hyperkit.co.uk

Jewboy Corporation™
i@jewboy.co.il
www.jewboy.co.il

Joe Marianek
joe@joemarianek.com
www.joemarianek.com

Julian Morey Studio
julian@abc-xyz.co.uk
www.abc-xyz.co.uk

Julie Joliat
julie@joliat.net
www.joliat.net

karlssonwilker inc.
tellmewhy@karlssonwilker.com
www.karlssonwilker.com

Kayrock Screenprinting
kayrockscreenprinting@gmail.com
www.kayrock.org

Kelly Verhallen
kellyverhallen@hotmail.com
www.kellyverhallen.com

The Kitchen
access@thekitchen.co.uk
www.thekitchen.co.uk

Loa Audunsdottir
loa@deluxe.is
www.deluxe.is

Masa
info@masa.com.ve
www.masa.com.ve

Michael Gillette
m.gillette@sbcglobal.net
http://michaelgillette.com

Misprinted Type (Eduardo Recife)
recife@misprintedtype.com
www.misprintedtype.com

Modern Dog Design Co.
info@moderndog.com
www.moderndog.com

NB: Studio
mail@nbstudio.co.uk
www.nbstudio.co.uk

No Days Off
info@nodaysoff.com
www.nodaysoff.com

Ohio Girl
andy@ohiogirl.com
www.ohiogirl.com

Pentagram
email@pentagram.co.uk
www.pentagram.com

Peter and Paul
paul@peterandpaul.co.uk
www.peterandpaul.co.uk

RD Granados
rdg@stereotypehaus.com
www.stereotypehaus.com

Ralph Schraivogel
info@ralphschraivogel.com

Rejane Dal Bello
rejane@dalbello.com.br
www.dalbello.com.br/rejane

Ryan Boblett
ryanboblett@hotmail.com

sagmeister.inc
info@sagmeister.com
www.sagmeister.com

The Small Stakes (Jason Munn)
info@thesmallstakes.com
www.thesmallstakes.com

STRIPE, Los Angeles (Jon Sueda and
Gail Swanlund)
jsueda@sbcglobal.net/
gailswanlund@sbcglobal.net
www.stripela.com

Studio Oscar (Oscar Wilson)
info@studiooscar.com
www.studiooscar.com

Sweden Graphics
nille@swedengraphics.com
www.swedengraphics.com

This Studio (David Bennett)
info@this-studio.co.uk
www.this-studio.co.uk

Tom Rothwell
rothety@yahoo.com
www.ptobe.com

unfolded
we@unfolded.ch
http://unfolded.ch

Uwe Loesch
contact@uweloesch.de
www.uweloesch.de

Vår
var@woo.se
www.vaar.se

Vault49
info@vault49.com
www.vault49.com

Walse® Custom Design Co.
henke@walsecustomdesign.com
www.walsecustomdesign.com

WeWorkForThem (Michael Cina and
Michael Young)
www.weworkforthem.com
www.youworkforthem.com
www.trueistrue.com

Woo Agentur (Dennis Eriksson)
dennis@woo.se
www.woo.se

Zip
info@zipdesign.co.uk
www.zipdesign.co.uk

Acknowledgments

Many thanks once again to all the designers around the world who took the time and effort to contribute their work to Poster-Art. Without them this book would not have been possible. In no particular order, a special thanks to Jason Munn, Robynne Raye, Uwe Loesch, Philippe Apeloig, Jonathan Ellery, and Wolfy and Kayrock at Kayrock Screenprinting. Many thanks as always to the design and editorial team at RotoVision, especially Lindy Dunlop and Tony Seddon, and to photographer Simon Punter, and designer Simon Slater who have done an excellent job with Poster-Art.

This book is for Mum.

Index